"This book should be required reading in every home across the country. It tells of the lost ones, the forgotten men who have given up on the American dream, and once we enter their crumbling, derelict world, our own world will never look the same to us again. Harvey Wang's photographs are superbly honest and raw. The testimonies gathered by David Isay and Stacy Abramson are little poems of desolation, vast hymns to the paradoxes of the human heart."

—Paul Auster

"Here is another side of the so-called American dream—the loser's side—in all its hopelessness and squalor, its alcohol-etched faces and brief broken stories—heartbreaking stories, most of them, because so worn to the bone, so honest, therefore so dignified."

—Peter Matthiessen

"This lovely and moving book may be the last record we will have of the old Bowery—maybe the last, too, of New York City as a refuge for outcasts. Every human story in here is singular, and every one stands in for thousands, perhaps millions, of unrecorded others."

—Luc Sante

"*Flophouse* is an extraordinary journey into a forgotten corner of America. Each of these voices and each of these images tells a story of loss and discovery—though sadly not always in that order. I laughed and wept, and felt so fortunate to have had the chance to make the acquaintance of these men."

—Alex Kotlowitz

"This book takes you to places you think you don't want to enter, to people you think you don't want to meet, to lives you think you don't want to live. And makes you rethink all

your assumptions. It reveals the tremendous strength and humanity of those who are usually ignored. And as you pay attention, your humanity expands."

—Susan Stamberg, special correspondent, National Public Radio

"A testament to the soon to be extinct New York subculture, the Bowery flophouse."

—*Vanity Fair*

"Sad, funny, provocative, and rife with self-destruction."

—*Brill's Content*

"An unflinching work of oral history . . . More than anything it's the stunning candor with which these men speak about their lives that elevates this book from a sociological curio to a meditation on the human spirit. . . . This collection is suffused with a quietly ferocious will to survive."

—*Bookpage*

"Of all the stories in this naked city, none are more naked nor so compellingly dear to the outcast legacy, now renovated and co-oped into oblivion."

—*Paper*

"A fascinating glimpse of men surviving at the forgotten fringes."

—*Men's Journal*

FLOPHOUSE

RANDOM HOUSE TRADE PAPERBACKS · NEW YORK

FLOPHOUSE

LIFE ON THE BOWERY

TEXT BY DAVID ISAY AND STACY ABRAMSON

PHOTOGRAPHS BY HARVEY WANG

RANDOM HOUSE TRADE PAPERBACKS and colophon are trademarks of Random House, Inc.

The chapter on the Sunshine Hotel was originally published in different form in *The New York Times Magazine.*

All photographs are by Harvey Wang, except for the photos on pages xiii and xiv (left), which are reprinted courtesy of Culver Pictures, and the photo on p. xiv (right), which is reprinted courtesy of Corbis/Bettmann-UPI.

Library of Congress cataloging-in-publication data is available.

ISBN 0-375-75831-3

Random House website address: www.atrandom.com

Printed in the United States of America on acid-free paper

9 8 7 6 5 4 3 2

First Trade Paperback Edition

Book design by J. K. Lambert

" 'The Alabama Hotel, the Comet, and the Uncle Sam House,' he said, in a declamatory voice, 'the Dandy, the Defender, the Niagara, the Owl, the Victoria House and the Grand Windsor Hotel, the Houston, the Mascot, the Palace, the Progress, the Palma House and the White House Hotel, the Newport, the Crystal, the Lion and the Marathon. All flophouses. All on the Bowery. Each and all my home, sweet home.' "

—Joseph Mitchell, quoting the Bowery's Eddie Guest in "Mazie," *The New Yorker,* 1940

"Whether in prosperous times or otherwise, experience has shown there is always an element of unfortunate, impoverished men, who are caught between the upper and nether mill-stones, as Civilization makes its tortuous way onward and upward. They are men who have met reverses, and so failed to achieve success, or who are passing through some ordeal or other, as they get out of step in the march of Progress, and all but fall by the wayside. Homeless, but usually courageous, they strive on—clinging tenaciously to their self-respect, and their confidence in the idea that better days are in store."

—From "The Industry Nobody Knows," a booklet published by the Lodging House
 Keepers' Association of New York, Inc., sometime during the Depression;
 discovered in the basement of the White House Hotel, 1998

This book started out as a radio documentary, "The Sunshine Hotel," which premiered on National Public Radio's *All Things Considered*. Many thanks to the funders of this program: the Greenwall Foundation, the Rockefeller Foundation, and the Corporation for Public Broadcasting. From NPR, thanks to Barbara Hall, Jean Connelly, Ray Suarez, Margot Adler, Jeff Rogers, Ellen Weiss, Jeffrey Dvorkin, and Kevin Klose. Thanks to Joan Nassivera and all of the good people at the *New York Times* "City" section. Thanks also to: Adam Moss, Fredrica Jarcho, Brian Byrd, Denise Gray-Felder, Julia Lopez, Jeff Ramirez, and Rick Madden. Thanks, as always, to Sound Portraits' technical consultant, Caryl Wheeler; to production assistant Suzanne Clores; and to our editor, Gary Covino. Special thanks to Nathan Smith and our good friend Charles Geter, who has been an inspiration to us throughout.

For help with putting the book together, many thanks to: Dan Hirsch, Neftaliz Betance and Betance's Deli, Andres Rosado, Arlene DeRise, Ted Houghton, Lucia Bruno, Joan Malin and the Bowery Residents Committee, Len Detlor, the New York City Department of Cultural Affairs, Kate Niedzwiecki, Michael McCabe, Carlos Briceño, David Perez, and our friend Bobby Connors, who died soon after this book was completed. Many thanks to transcriber Ian Lague. Special thanks to Meagan Howell at Sound Portraits for pulling all the disparate elements of this book together with energy and grace.

For photographic assistance, thanks to Colby Katz, Seth Goldman at Flatiron Color Labs, and Isa Brito for printing the black-and-white photographs.

Special thanks to Jane Isay; our agent, Jonathan Dolger; and our editor, Scott Moyers, for sharing our passion for this project.

Above all, thanks to the men in these old hotels—to whom we dedicate this book—for their openness, patience, trust, and kindness. They made us feel at home.

—*David Isay, Stacy Abramson, and Harvey Wang*

CONTENTS

From the end of the nineteenth century through the middle of the twentieth, the Bowery was the world's most infamous skid row. Under the shadow of the elevated Third Avenue line, the sixteen-block stretch of lower Manhattan was jammed with barber schools, bars, missions, men's clothing stores, slop joints (cheap restaurants), flophouses, and tattoo parlors. The estimates vary, but in its heyday somewhere between 25,000 and 75,000 men slept on the Bowery each night.

Today, the barber colleges are all gone. Al's, the last rummy bar on the Bowery, closed in 1993. There are no tattoo parlors, no employment agencies, no pawnshops, no burlesque houses, no secondhand stores, no El train. All that remains of the skid-row Bowery are a single mission and a handful of flops, still offering the shabbiest hotel accommodations imaginable for as little as $4.50 a night.

During the Depression, there were close to a hundred flops (the polite term is *lodging house*) lining the Bowery. Almost all of them were walk-ups, with a bar at the ground level and the hotel on the floors above. Up a steep flight of stairs sat the hotel's lobby—wooden chairs, a couple of benches, and some tables. Near the entrance was the cage, where the clerk sat with his ledger.

Beyond the lobby were several floors of accommodations. Guests had two choices: a cot in a tightly packed barrackslike dormitory (a little cheaper, a lot more bedbugs) or a cubicle. Smaller than a prison cell (about four-by-six feet and seven feet high), the cubicles offered nothing more than a bed, a locker, and a bare, dangling bulb. They were built in long rows, separated by narrow hallways. The walls between cubicles extended only partway to the ceiling, so each room was topped with chicken wire to discourage

The corner of Bowery and Delancey streets, 1934.

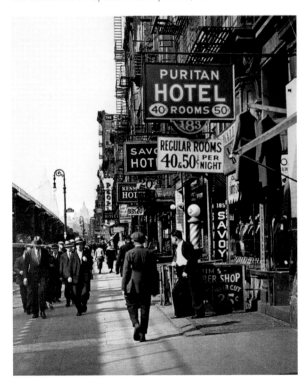

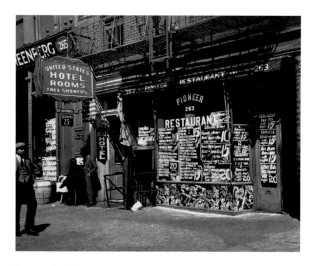

Bowery slop joint, 1934.

The lobby of the Comet Hotel, 1932.

"lush divers" from crawling over and riffling through a dead-drunk neighbor's wallet.

The skid-row Bowery grew out of the Civil War, which created homelessness on a vast scale. Cheap hotels for returning vets opened up in what was then a New York City red-light district, and before long the Bowery became a mecca for the nation's down-and-out. Seventy-five years later, the Second World War brought the street's skid-row era to a close. The Bowery's population plunged, as it always would in times of war. At the end of this war, though, returning vets were greeted by the G.I. Bill and other new social programs. Few became homeless. The flops began to empty out. By 1949, there were only 15,000 men left

on the Bowery. A 1955 change in the city's housing code prohibited the construction of any new hotels with cubicle-size rooms. Bars and slop joints and employment agencies were replaced by restaurant-equipment wholesalers and lighting-fixtures stores. Real estate values on the Bowery continued to rise; old flops were converted into residential lofts and office space. In 1966, there were 5,000 men left on the Bowery.

Today, about a thousand men remain in eight old flophouses: the White House, the Palace, the Sunshine, the Andrews, the Prince, the Sun, the Grand, and the Providence. The hotels are a fluke. While the rest of the skid-row Bowery was wiped clean, hous-

ing laws made it tough for hotel owners to empty the buildings. Some burned their tenants out. Some sold their hotels to a Chinese businessman, who uses his

Floor plan of the Providence Hotel.

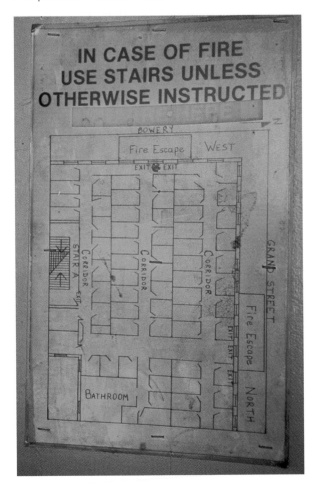

flops to house newly arrived Chinese immigrants. A couple of owners threw up their hands and decided to stick it out. The remaining flophouses on the Bowery are, at least physically, a nearly perfectly preserved remnant of old New York.

This book profiles fifty men from four of these hotels, each one a self-contained society of more than one hundred residents. Most of the flops' staffs (clerks, porters, etc.) live on the premises. Some residents go for weeks without leaving their cubicles, relying on the hotel's runners to bring them food and cigarettes. Part prison, part way station, part shelter, part psychiatric hospital, part shooting gallery, part old-age home, each hotel has a distinctive character and clientele. They are fascinating places, inhabited by the last residents of a world soon to vanish.

FLOPHOUSE

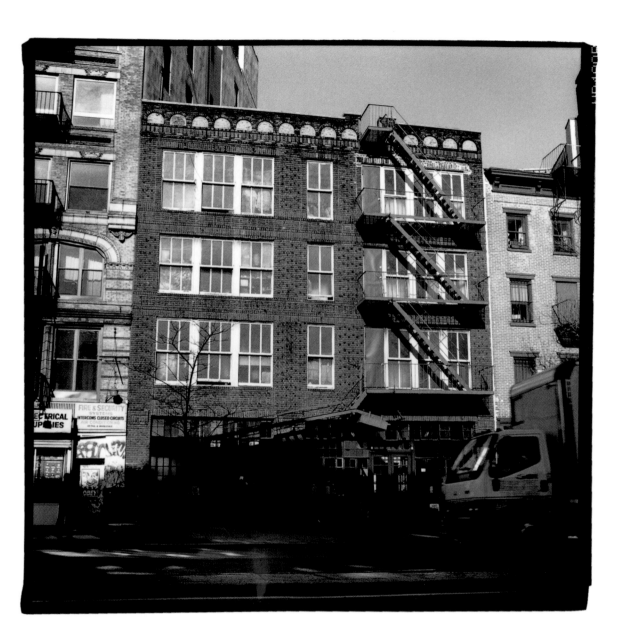

THE WHITE HOUSE HOTEL

340 Bowery

The four-story White House was opened in 1917 by Euzebius ("Zeb") Ghelardi and remained in the family until Zeb's grandson, Mike Ghelardi, sold it in 1998. For most of its history, the hotel was whites-only—it's rumored that the flop got its name that way. One of the few flops with a lobby on the ground floor, the White House is the safest and most genial of all of the hotels on the Bowery today. It is also the most expensive, charging fifteen dollars a night for a cubicle. About two hundred men sleep in the White House each night.

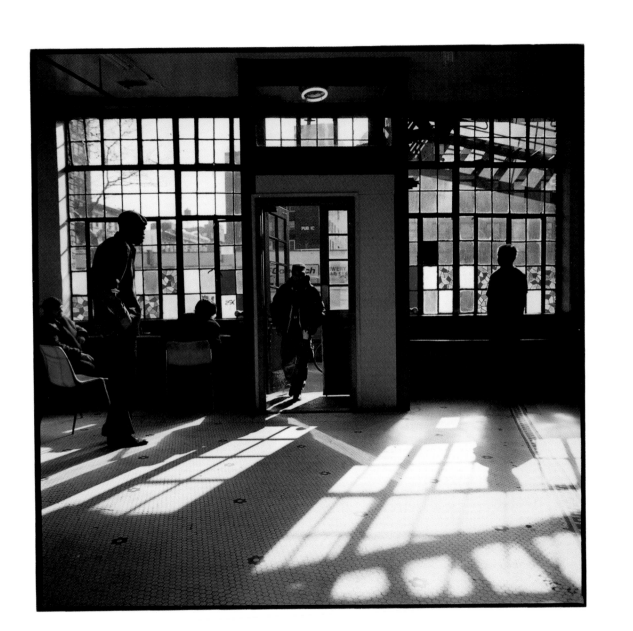

This place? This place is a respite for the weary on the run from life. How did I get here? That's your next question, right? I don't know. I really don't know. It was slow and methodical. As Shakespeare would say, my too too solid flesh melted and thawed and is resolving itself into a dew.

Let me see . . . I was a professional student—went to NYU, Cornell. Studied economics, history, government. Then I acted, wrote plays. Never found my niche. Worked on Wall Street climbing the corporate ladder. I was moving up to be an executive in a bank tax department when I went bananas. It's a well-told tale—I lost the apartment, the wife. Tried to destroy myself, because I felt like a failure. Attempted to drink myself to death, but I couldn't do it—liver wouldn't fail, gut wouldn't fail, nothing failed! That's a failure within a failure within a failure—incredible! So I came here to rest my head and get out of the rain.

There's nothing sublime about this place. It's nothing. People waiting to die. They come here for a night and neglect to put a calendar on the wall. Ten years later, they forget that they were supposed to move out. They're just not cognizant of time moving on. Time is of no element here. That's why the clock is so small on the wall—they purposely keep it that way, so you'll never walk out.

I can't stop drinking. That's my lady. That's my woman. I call it exotic escapism. So now I play a lot of chess. I'm one of the best black chess players on the East Coast. And I work as a dishwasher. The guys call me "the intellectual dishwasher." Can't beat that, can you?

But, listen—before you go, I want to explain something: My wife never left me. I left me. Do you know Jean-Paul Sartre's *Being and Nothingness*? I decided on nothingness, because my being wasn't being fulfilled in the way that I wanted it to be. So I set out to be nothing. And here I am. I've arrived. Nothing. *Nothing!*

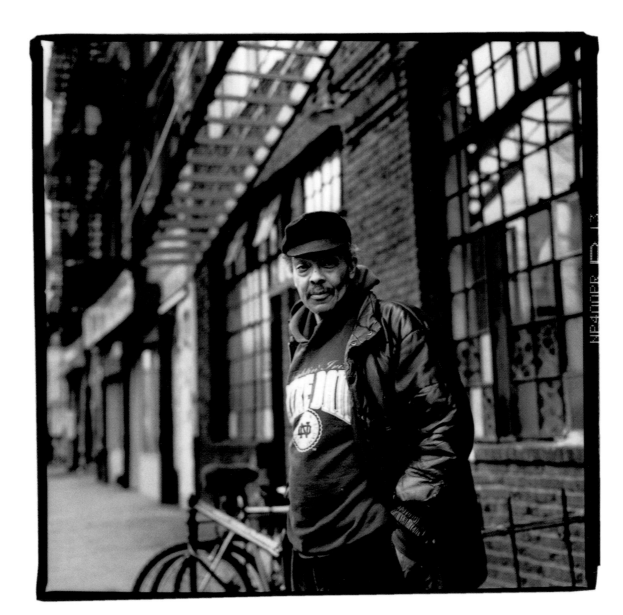

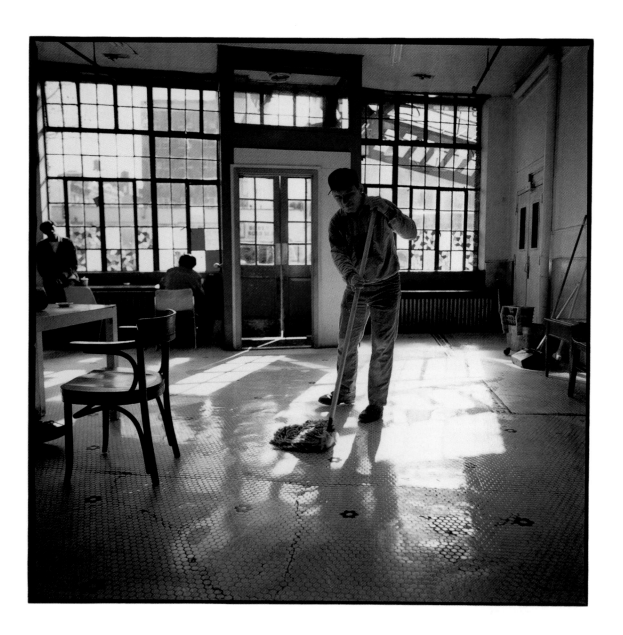

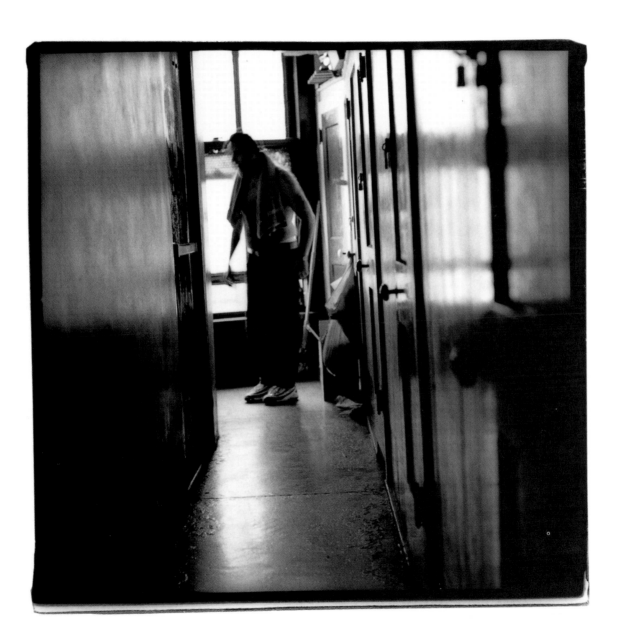

My grandfather built this place with his brother in 1917. In '52 my uncle took it over. When he died eighteen years ago, I came here to serve the poor and to serve God.

This is a completely unexpected place. When you walk in the door, you're walking through a time warp. I think of it like a medieval community. In medieval towns, everyone lived together like family. The lame, the infirm, the warped, the sick—they were all accepted. And that's the way it is here. There's two hundred guys of every conceivable talent living together as equals. It's the only place I've encountered like it in the modern world.

For instance, we have a guy upstairs called the General, who's lived here ever since I can remember. He's from Poland and is mentally ill. One day he was hit by a car and taken to the hospital. He had no ID, couldn't communicate, and he just disappeared for two or three years—no one knew where he was. Then, a few weeks ago, he walks through the door. The whole place erupts in welcome. Now, this is a man who stands around looking at the wall all day—but the place erupted! We hugged him, he smiled, he was happy to be back. That's the way it is here.

When I started here I was a very religious guy, and I took over this place for my soul. My vision was that the poor would be grateful if I helped them. But when you're dealing with people who have nothing, a big percentage will try to take from you. And now the financial pressures are just overwhelming. It stayed in the family up until now, and unfortunately I'll be the guy who has to liquidate it.

Even though I've gotten cynical about human nature, I still care about the guys here. Not all the guys—there's a lot of jerks—but most of the guys. They appreciate a good bargain, and they act reasonably. That's the reason I'll be sorry to leave.

Mike Ghelardi sold the White House in May 1998.

The General.

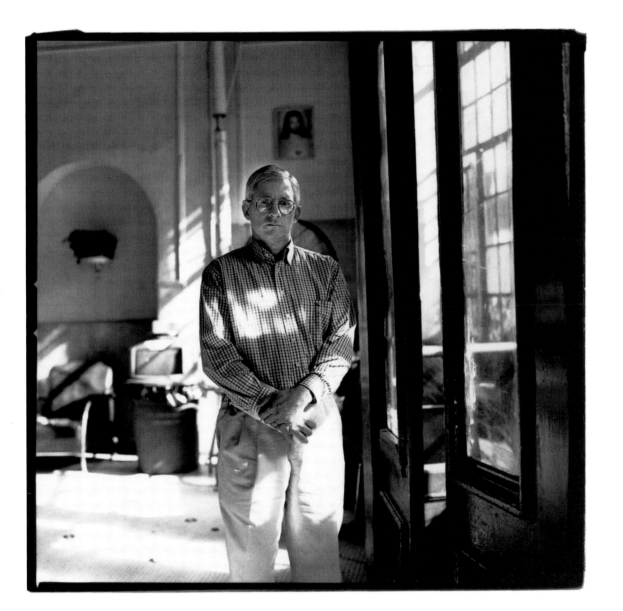

I'm from Poland. I came to United States seventeen years ago. 'Eighty-three, I think so. I came here to study economics. Ph.D. program at City College. I was accepted at a few other places, but they offered me best deal. I started very well. Was teaching at City College, at Brooklyn, at Manhattan Borough College, at Hunter. Pay was not bad. I did second year, third year. Fourth year, me and my wife decided to move for a while to Washington. Then I left good job in Washington to help out my family—my father was dying and my sister had multiple sclerosis. Went to Poland and I had to stay with them almost five years, 'cause they were a mess. And my relationship with my wife started to be worse and worse, so we got a divorce through the mail.

I came back in '94, and that's when my suffering started. I was very disappointed in many things. Lack of money. Friends were gone. I was lonely. I didn't have the means or the energy to complete my dissertation. I didn't have money in my pocket, so I had to start immediately working again—selling books on the street and working in liquor store. With my income I couldn't afford to pay New York City rent, so I came here.

Right now I'm hiding from everybody. Like a snake—that's expression from my country: "like snake hides its legs." Nobody can see them. Because I am ashamed. I am responsible. I left the Ph.D. program. I left good job in Washington. For long time I keep sending my résumé out, but last five, six months I give up. I know lots of people suffer, so I'm trying to be tough. I'll be out of here sooner or later—maybe two months, maybe two years. If I don't think so, I would kill myself right now. Right now.

Misha M. asked that his face not be photographed.

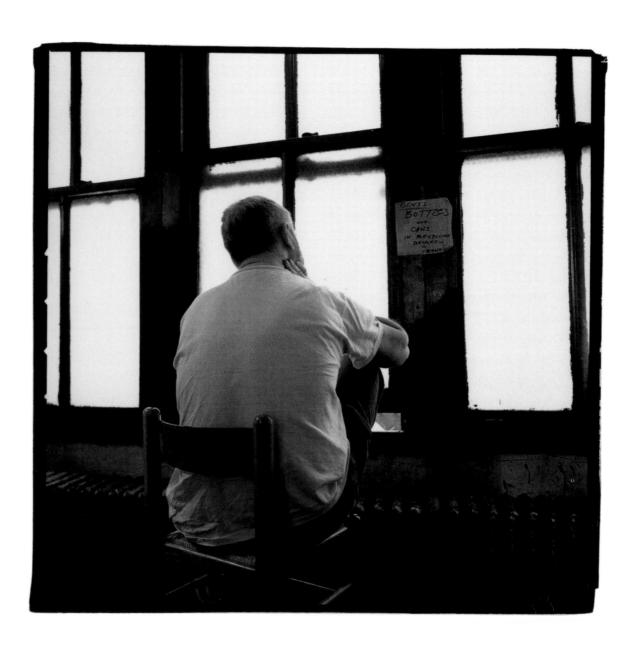

work. I believe in hard work. I don't care what the job is, I believe that every able-bodied man should work. Right now, I do independent recycling. I get out there with my cart and my map and I pick up redeemables such as plastic cans, bottles, and aluminum cans. That takes skill and organization. You got to know when to work residential, when to work commercial, how to weed the garbage cans and how to know if somebody's been there ten minutes ahead of you. You have to keep charts so you know when to hit certain spots. You have to find out about all city activities—like parades and street fairs. Usually I work for eighteen hours and bring in up to a hundred dollars.

I've seen people who have been doing this for years and they're physically beaten—they've never elevated past pushing the cart. So everything I'm doing now is for my van and my storage room. The van will let me cut down on my time. The storage room means I won't have to redeem immediately—because there are certain things you can't redeem at your basic recycling center. So I'm building my business.

I have some unique qualities of organization that make me better than some, but there are some people who get out there and make me look childish, because they're so good. King Willie is the best I've ever seen—he goes out there and makes two to three hundred dollars a night. But he's a compulsive gambler, you see. Sure he can go out and make that money, but there's the physical wear and tear that it takes for him to make it, and then he turns it all over to the OTB. Whereas me—I can go and buy a pack of cigarettes, go back to my room, go to sleep, and wake up with all my money and start fresh all over again. So that gives me the advantage of being consistent.

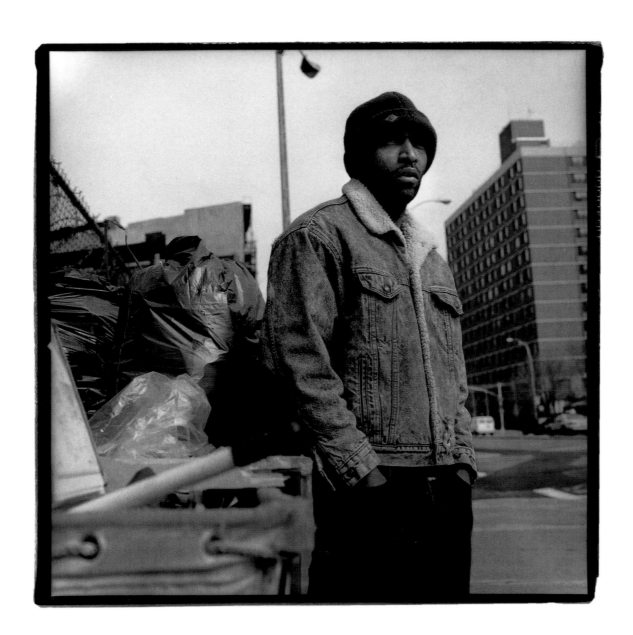

started sniffing glue when I was ten. There were these kids from Brooklyn that I was hanging out with, and they got me into it. I'm pretty sure it gave me brain damage. I think it destroyed certain areas of my brain—like choice-making. Maybe that's why I started drinking beer. I started to drink a lot. One year I stole a Christmas gift my mother intended for my aunt—a carton of cigarettes—and she said, "That's it! Get out!" So I moved in with the wrong people and got addicted to heroin. Became a heavy needle-user. Had hundreds of jobs—a jack-of-all-trades, a master of none. One day I'm driving a truck and OD behind the wheel. Pretty soon I'm homeless.

I been here two years. Right now my self-esteem on a scale of 1 to 10 is, like, a 4. I know I'm overweight. And I'm a loner. And my spiritual backbone is lacking. But I think my self-esteem is coming back a little bit. A little bit. This is the first time in years I've been domesticated—you know, sleeping in the same bed indoors. I have health problems, so I can't really work, but I take care of the lobby. Like, if I see the ashtrays are full, I'll empty them, or the garbage cans. But I'm not really content. I sit at the window and drink coffee and think, Is this it? Until I die? But the damage I've done to myself is all from my own hands.

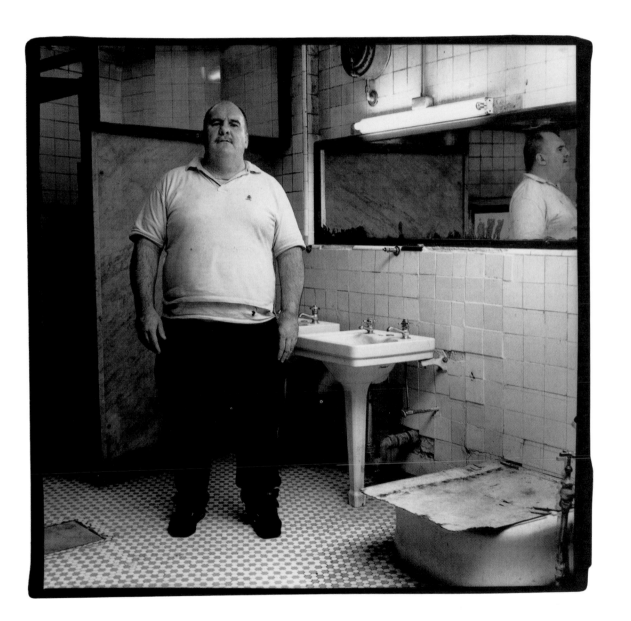

I'm Jerome Siegal, and I'm fifty-eight. I'm originally from Boston. I had a good childhood, a good adolescence and good young adulthood. My father was quite religious—he taught Hebrew and was sort of a lay rabbi and a professional cantor—so I come from, I would say, a very spiritual father. And my mother, too, of course. Yes, they were good parents, very good parents. I went to college—I'm a college graduate—and I was trained to be a teacher.

I got sick in my early twenties and I became sort of a self-imposed outcast. I had chronic schizophrenia, and it left me sort of autistic socially. I was terribly unhappy and I was a friendless, reclusive person, for years. So this place was a good out for me.

Since I came here I've become, over time, sort of a poet. I have a routine: I go to bed around eight o'clock at night and then wake up at midnight and write about my everyday experiences—sort of journalistic poetry. I keep my notebook in a suitcase under my bed. I feel my poetry is safe here.

When you live in a place like this, you need to get out. I used to hang around these empty churches and just sit and contemplate. I used to go to the Hindu shrine every week and to the synagogue regularly. Nowadays, I go to a Talmud class once a week and to church every Sunday to confess. When I was sick, the spirituality carried me through. Me and God walked the Bowery quite happily over the years.

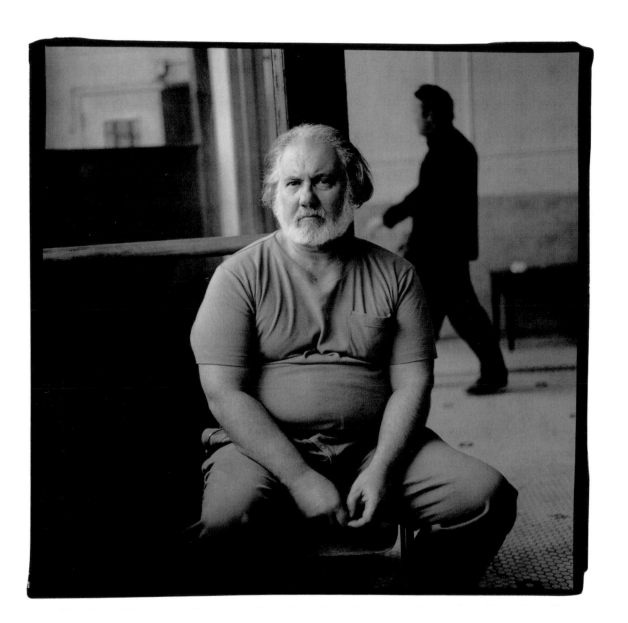

The first thing I would like to say is thanks to the President of the United States for this opportunity to speak of my experience in America as a veteran of the Korean War. A lot of shrapnel and whatnot is still in this old body, but I believe in the people and their leaders and I believe in freedom.

I grew up as a black kid in Baltimore. My father worked the steel mill. He thought that he was God. He would go to the bar after work and drink, and as a boy I had to go and bring him home, because he had to go to work the next day. I didn't want to be like

Mr. Jackson shining shoes outside of the White House.

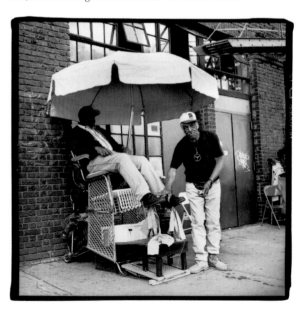

him, so I started when I was four years old shining shoes. My uncle gave me a dollar to get the polish. He was like Moses. I say that because he had come to free me. "I heard you want to shoe-shine," he said. "You gonna go places."

I've been here since 1953, when I came back from Korea. I fell into the alcohol thing and came down here to deal with those problems. I fell in love with the Bowery. When I wasn't here I'd miss it, just like a secret girlfriend. The winos laying on the street— they was happy because no one bothered them. They'd say, "I want to be here, free and alive, the wife not chasing me around the kitchen, not putting so many demands on me!" It was freedom. It wasn't like Christmas once a year; it was Christmas every day.

In 1970 I quit drinking and started to shoe-shining. I been all over Manhattan shining. Years ago I used to be at Fifth Avenue and Forty-second Street by the library. Now I shine outside of the White House. I come down at five o'clock in the morning and sit here, and peoples come over and talk. It's like a family. Don't you feel something here? Don't you feel the presence of strength? The power of mens? You get a feeling that if one survives, we all gonna survive.

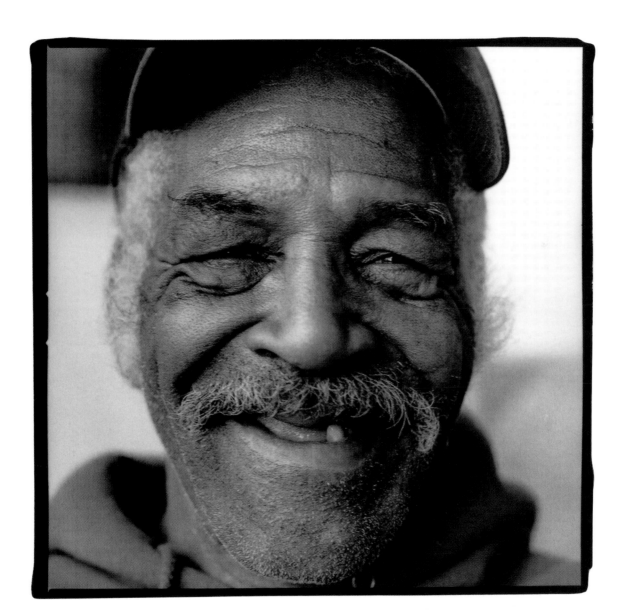

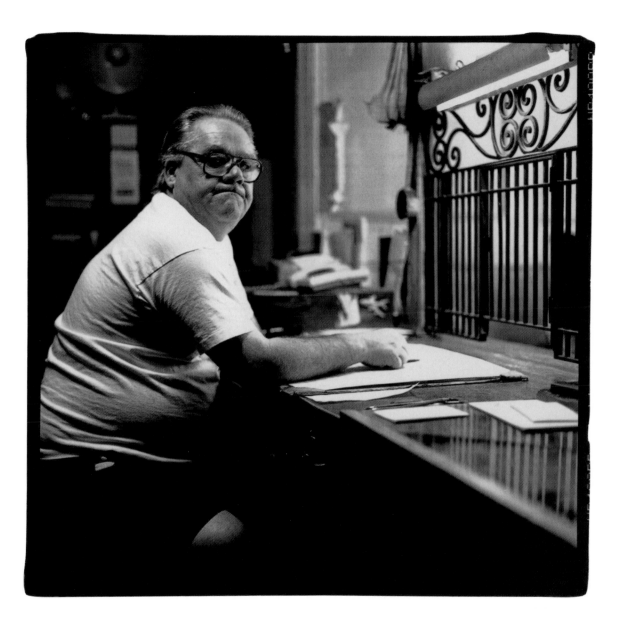

I ended up here because I was on the outs with my family and I wanted to start a new life. I wasn't addicted to drugs or anything—I just needed to get some things out of my system. I'm also diagnosed bipolar, so I guess some could contribute me being here to mental illness. I'm sure there are some in my family that would actually say that. But it's not that way at all.

Being here on the Bowery has been a totally fantastic experience. I feel that this is a place to find yourself. You're just dropped here like a puppet with all the strings taken away, and you have to survive on your own. It's such a . . . *growing ground.* There's no book you could possibly read that can teach you more than watching the human animal starve himself of everything in a place like this. Every man's got a story. Like, I got a guy upstairs. I call him John the Mad Bleach Man, because every night at three in the morning, he'll wake up from his sleep and wash the floor with bleach. Every night! And you got to cover your nose, because the fucking bleach is burning the shit out of you. The other day he told me how his mother would wash his things in bleach, so last night when he's doing it, I'm thinking, "What the fuck did she actually do to him with this bleach? Why is this bleach so ingrained in this man?" So it's just a fascinating place. I just love it here. I feel like I'm in the class of '99 from the Bowery.

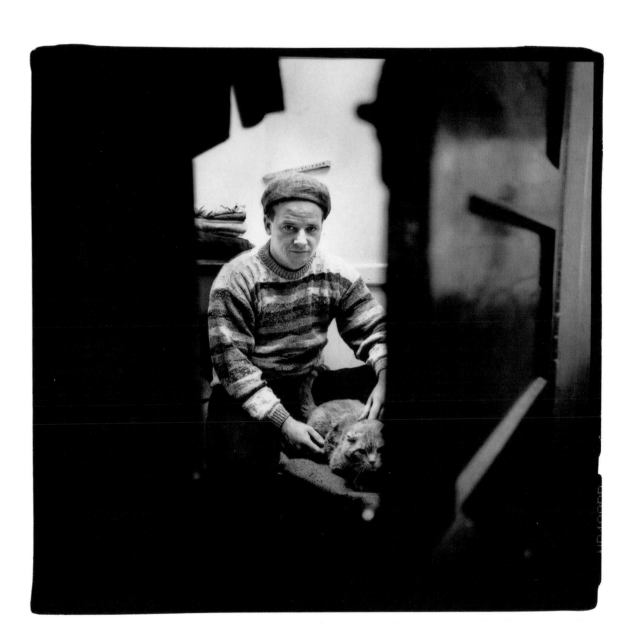

I was born in Puerto Rico and came to the United States in 1953. I'm a mechanic—I do bodywork, you know? If the fender is crooked, I put it the way it used to be. If there's an accident, I make the car back perfect again.

I used to own a garage and I worked in that until I fell into drugs. I had this client—I used to paint his car. One day I asked him what he was doing, and he said, "Taste and you'll see." And I didn't know anything about drugs. I took two hits and I saw the whole world rose-colored. Everything was easy, and I could do anything. My wife found out, there was a big commotion, and she left me. Curiosity killed the cat.

I've been here eighteen years. A long time. Too long. But I'm not afraid of death. Because the more you're afraid of death, the faster you die. You see my motorcycle over here? I used to stand on the seat of my Harley in Puerto Rico and the motorcycle would ride by itself. I'm not afraid of nothing.

This interview was translated from Spanish.

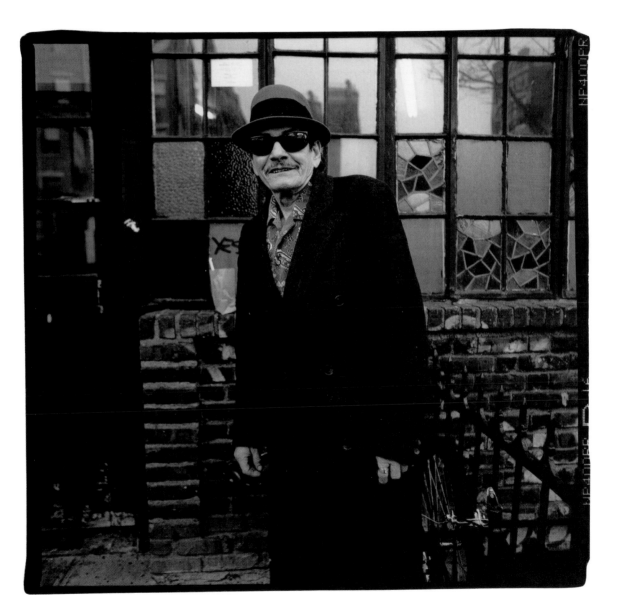

I was born January 8, 1929, on the Lower East Side. My mother was there, of course. My father? Who knows? I had the very good deal of being born on a dining room table. It was very nice, very polished—an antique. I was born Jewish, and I'm proud of it. Over here I have *The Joy of Yiddish,* the Torah, the Holy Bible. I have two mezuzahs—actually three. I pray every day. I say, "Dear Lord, please have patience with me, because I'm such a fuck-up."

I started hanging out down here when I was in my forties. I was all for drinking and having fun. I was living uptown, working in the real estate business, and I didn't want anybody up there to see what I was doing. It was more open on the Bowery. You could do what you want and you didn't give a damn who saw you. For many years, I would come and go—you know, stay one or two nights. Finally I moved here. Came down to the White House about fifteen years ago. I got Room 116. Been in it ever since.

There used to be quite a few hotels down here, and quite a few bars, too. You could buy wine for a dollar a bottle and sit there with your friends. In the morning they used to have what they called "the eye-opener"—two glasses of wine for twenty-five cents. They would have razor blades for the customers, and we were allowed to wash our faces and shave in the back. Years ago, there was no such a thing as drugs on the Bowery. Drunks were the main thing. If you were an alcoholic, you came down here. See, the Bowery is a place, but it's also a state of mind. People feel worthless. They don't give a damn anymore. They're in the Bowery state of mind.

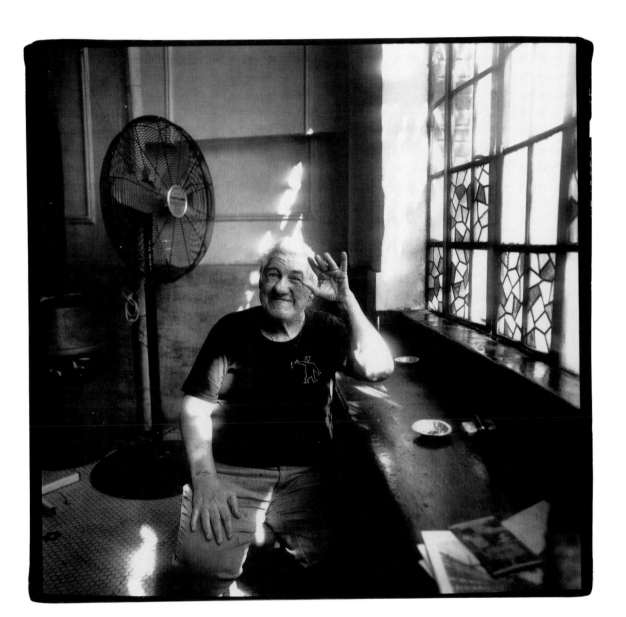

I'm an artist. I speak two languages fluently and sing in seven. Duke, Count, Schubert, Beethoven, Tchaikovsky—I sing art songs. I was born listening to soul music, but Schubert and the others gave me so much more than that—they're outstanding.

The Bowery? I just danced into it. I had no place to go. I was living in the Hotel Royal, uptown. Someone kicked in my door and they refused to replace it, so I refused to pay the rent. Next thing I know, I'm walking the streets. To tell you the truth, it didn't bother me at all. You see, as an artist you have to expect everything. Nothing surprises you. Although I must admit, the way they sleep in the streets and eat food out of garbage cans—that surprised me.

Then I found this place. Been here for two years now. My first day, I sat right over there and everybody came by and gave me *the look*. You know, the "Don't mess with me" look. I wasn't gonna mess with them. Didn't even speak to anybody for the first three or four days other than to say, "Excuse me."

To me, this place is like a movie. It's not real life. It's existing on the edge. You got the nowhere man with the nowhere plan. You got the liars, the bums. And the rooms aren't even as large as cells. It used to be a joke: "I have to step outside my door to put on my trousers." But it's the truth—I have to step outside my door to put on my pants!

I hope one day you hear me sing—I really do. At the moment I'm not singing anywhere, but if I do, I sure hope you'll come. It'll be an experience. All that matters today is that you have a rocking beat that makes people move. But mine is . . . *quiet*. When I sing, everybody shuts up, because they wanna hear. I'm trying to make beautiful sounds. I'm squeezing them out of my heart.

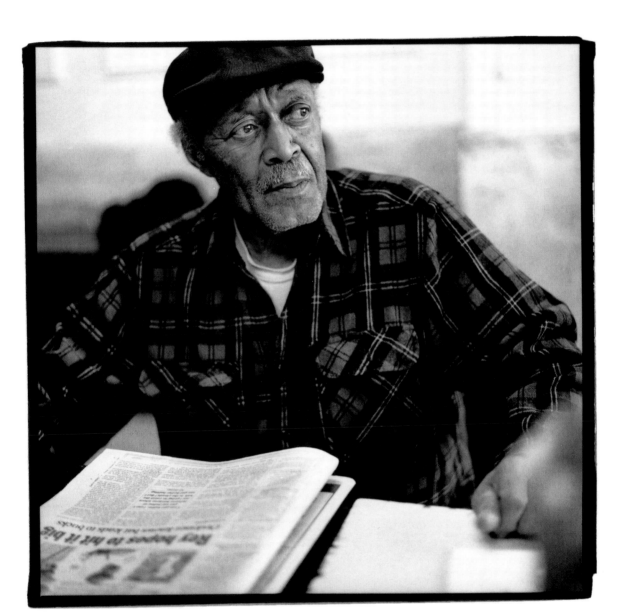

'm Robert Connors. Bobby Connor. Bobby O'Connor. Bobby Connors. I'm a heroin user and pill-head, and I have an attention deficit disorder—hyperactivity with the rapid speech. I'm forty-four, grew up in Bay Ridge, Brooklyn—a nice neighborhood. And I'm an ironworker by trade. I come from a whole family of ironworkers—my father was an ironworker, my brothers are ironworkers. I worked on every bridge in New York. I busted rivets out for seventeen years, and I was considered one of the best rivet-busters in New York City. An authority. To cut to the chase, at the age of thirty-five I had the world by the balls: I worked for the Department of Transportation, I bought stocks on the Nasdaq, I was sober. So I said to myself: "I'm working on the bridges, I'm making fifty-two grand a year—I can handle this job drunk." And that's exactly what I did. I worked for years on the bridges—drunk and popping pills.

At the age of thirty-eight, I started going to the Providence Hotel out of convenience. I was working on the Williamsburg Bridge and I said, "I can go to the hotel dirty, wake up with a hangover, shower, and go to work." I was into pills at the time: Percocet, Darvocet, benzos—the whole nine yards. Anyway, it got out of hand. I took a seizure, and I fell off the Williamsburg Bridge and landed in the net. I blamed it on MSG and the Chinese food, but my boss wasn't going for it, so I lost my job.

I'm optimistic about getting it together. I read the Bible every day, and I get on my knees and pray to God to end this obsession with drugs. I go to a church every night—even under the influence. I've never lost my union card, and my whole family's rooting for me, even though I've burned a lot of bridges. I'm only forty-four, I have no criminal record, and, you know, I consider myself—people tell me, anyway—"You're a hell of a nice guy." They tell me, "Bobby you seem like a stand-up guy—what the fuck is the problem? Can't you get it together?" And even though I have an addiction problem (not to sound redundant, but I been on pills and heroin for twenty-five years), I was always blessed with a good heart.

Bobby Connors died on October 29, 1999.

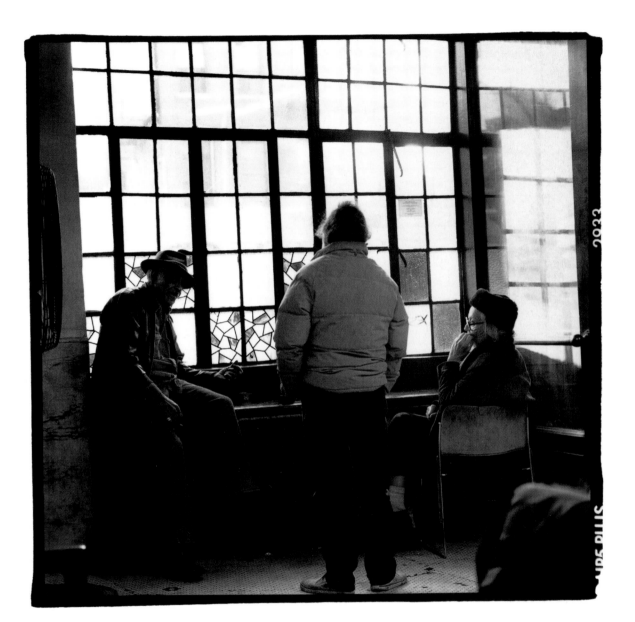

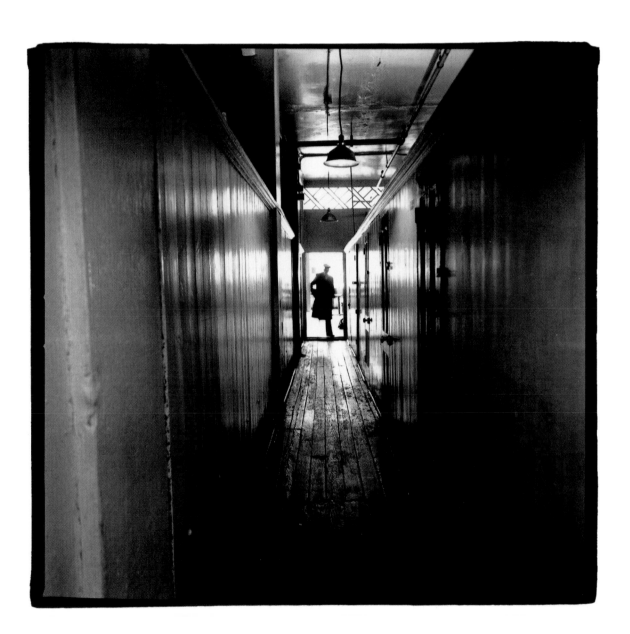

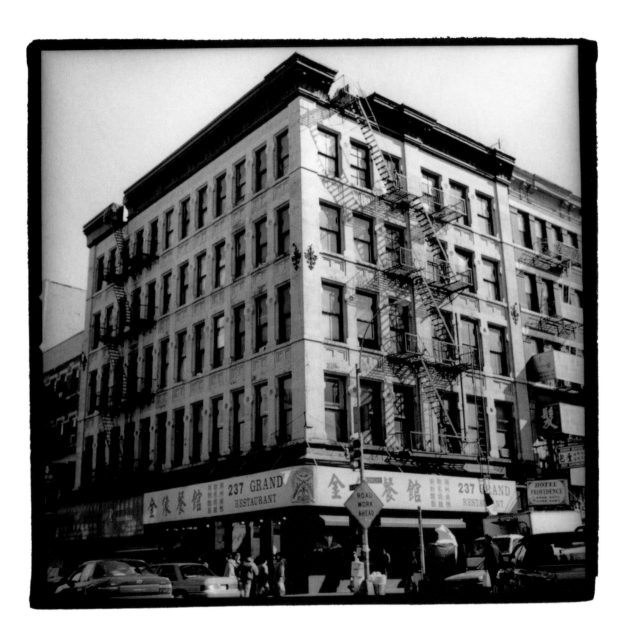

THE PROVIDENCE HOTEL

The five-story Providence Hotel has operated as a lodging house since 1895 (it was originally called the Equitable, and then the Owl). Today, it's one of the most notorious and drug infested on the Bowery. The owner, Sze Yin Tam, wouldn't grant us access, so we posed as guests and rented cubicles to get interviews. Bobby Connors from the White House, a former clerk at the Providence, acted as our guide through the hotel. It sleeps two hundred men on four floors.

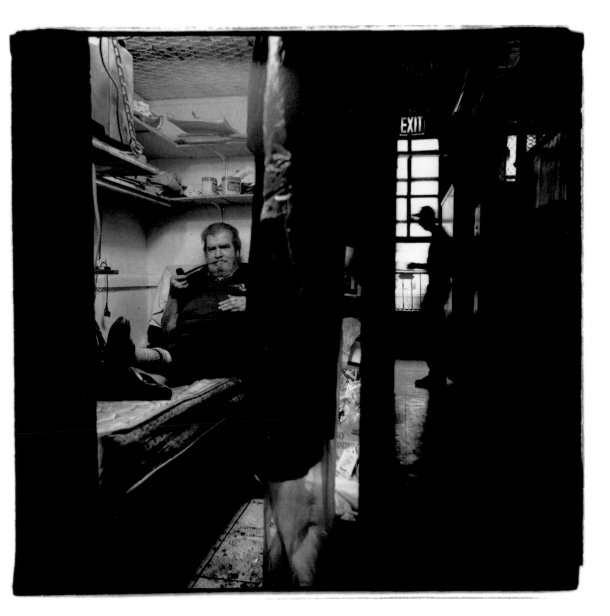

I grew up in Bed-Stuy in the forties. Started gambling in 1942, when I was seven years old, shooting dice under a lamppost. I know dice. Dice is my game.

I had my own dice games in Brooklyn for years. I

Jack Smith's door.

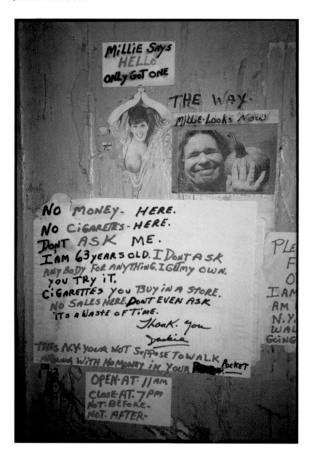

did loan-sharking and bookmaking. Been arrested fifty-one times in my life, but I just keep going. I'm sixty-three now and I still got no ailments. Blood pressure 120/80. I can do push-ups and I can fight young guys—I floored a twenty-eight-year-old with one hand not too long ago!

I believe you gotta have earning power. Maybe I don't work no more, but I still got little things I do to make an income. Like cook and sell sandwiches out of my room. They're very cheap: meatball a dollar, sausage a buck and a quarter, chicken or veal a dollar and a half. They eat, I put it on a bill, and they pay me. I survive pretty good. Never late with my rent, always on time. You always gotta pay for the roof over your head. My father taught me that.

I go to Atlantic City every month. I went December, January, February, and March already. This month I blew $10,400 that I had tucked away. But I'll be back there April fourth with another $2,500 I'll finagle. I enjoy gambling whether I win, lose, or draw. I lost $2,600 the other day—it don't bother me. Since I was a kid, I gambled seven days a week. That's my life, gambling.

Do I want to stop? What, are you crazy? You want to stop breathing? I'm going for the big one now. Just let me win a million and I'll have the biggest party of my fucking life and then I'll hit my casket a happy man.

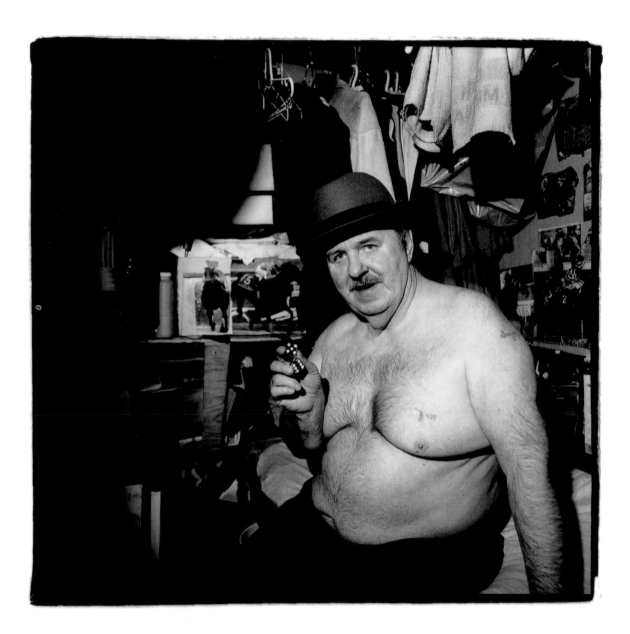

My wife was a nurse, and she used to work at night. She had had surgery previous to my marrying her and got addicted to morphine. She was stealing it from the hospital and doing it when I was at work, so I didn't know. When I found out, it upset me so much I started going to group therapy. But eventually I started doing it myself, and I got addicted very quickly. After about a year and a half, we moved on to heroin.

Within four or five years, I had a serious heroin addiction problem—about two hundred dollars a day. I had been a chemical-lab technician for many years, and I lost my job. I lost my old farmhouse up in Goshen, New York. My car and my pickup truck, I lost. So things were pretty bad. We started living in a car we had on the streets of New York City. She would work part-time, I would work part-time, and we'd spend all our money on heroin and crack. On a Christmas Eve, my wife and I both got busted. Her folks came and bailed her out of jail. They left me there. I never saw her again.

When I got out, I lived for a while in an apartment in Harlem for five dollars a day—I'd go out and shoplift to pay the rent. I stayed there the whole summer waiting for my wife. She never showed up. So I moved into Central Park and lived under a rock outcropping. When it would rain, there was a building they were reconstructing on 109th Street and Fifth Avenue with a cement block missing from the foundation—a twelve-inch block—and I was so thin, I could slide underneath that cement block and get in the basement to sleep. When it got cold I went to a shelter, but it was a real horror of a place, so I came here. That was eleven years ago.

This is a very destructive place. I go to detoxes and rehabs, and as soon as I come back, someone says, "Hey, Frankie, you want a drink?" They sell drugs right over there, you know? I don't know how many people I've seen here that have overdosed. They've had guys that snuck up girls that overdosed in their room and they just drag 'em out in the hallways and leave 'em. So many bodies. In the last year, two people have gone out the window. One guy jumped about a month ago, and someone pushed the other guy out. He bounced off the fire escape and landed on almost the exact same spot as the first. So it's a pretty depressing place.

I just got out of Staten Island University Hospital. I spent nineteen days there—detox. Then rehab. This is the second time that I've graduated from their program. I got twenty-one days straight now. It's the first time in four years, and I feel really good about it. This time, I really think I got it. Perhaps this summer I'll get myself another place to live. Possibly that's what I'll do. I just hope things get better. You have to have hope.

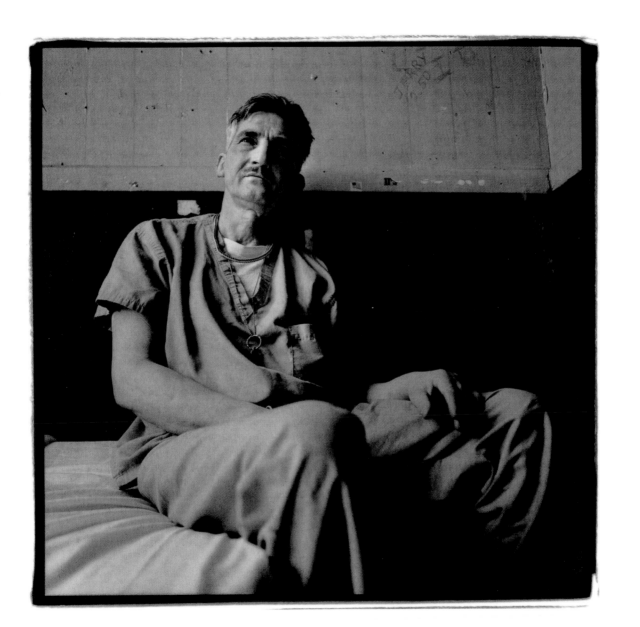

I'm from Zagreb, Croatia, and I'm Muslim. I came to the United States about four years ago, after I lost everything in Yugoslavia. My house was burned down by the Serbians. They came, tied us all up, threw us to the ground, and beat us—I was swollen from head to foot. And they made us just sit there and watch them destroy the house. They killed all the animals—the pigs and the cows—and they cooked them up to eat and they had a fiesta. They became drunk. We were really lucky we had no young girls there, because they would have raped them. So, you know, it wasn't exactly a pleasant sight. And mentally, it completely blew my mind.

At the time, I was working as an artist and also working on the farm. They destroyed everything, and my family scattered through the countryside, so I left.

When I came to America, I was totally destroyed. I ended up going on the street and becoming a junkie. I started shooting heroin and smoking crack. I went from being an artist to a thief in the night, you know? I had no sense about me. I'd steal to survive and supply my habits. Eventually I found this place, and I was able to graduate myself slowly off the drugs. So right now I'm doing a little better—delivering chickens from a fast-food store for $2.50 an hour and starting to draw and write again.

This is a noisy place. I'm still sorting out my mental problems, and I need quiet for my depressions.

This floor is a little different, because most of the people are workers, but people upstairs are dealers and thieves and robbers. I never feel secure. This chicken wire on my ceiling is nothing—I always think somebody's going to come through. You gotta understand, most of these people have mental problems, otherwise they wouldn't be here. For me, the hotel is a temporary security because it's out from the cold—but there's got to be better than this.

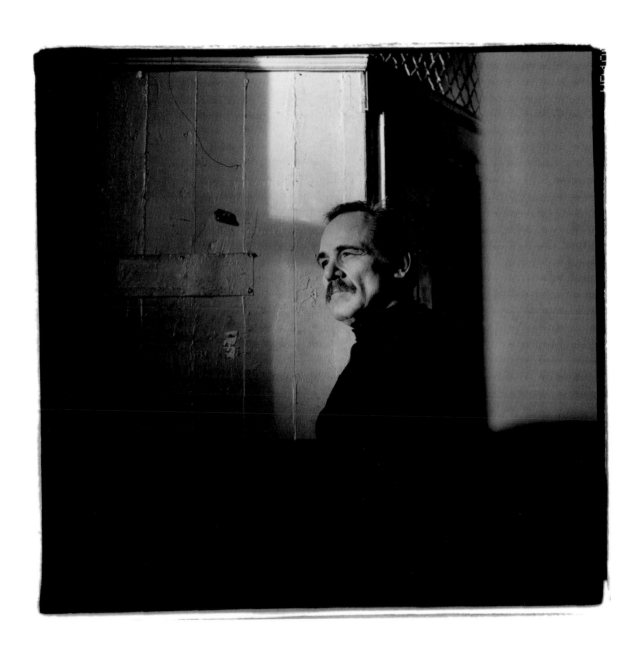

I grew up on the Uintah and Ouray reservation in Utah, about 150 miles east of Salt Lake. I was curious and I wanted to travel, so I left home when I was seventeen. First I went west to L.A. and traveled up and down the coast—Seattle, Washington, Portland. Then I went east to Miami. But all the time I heard so much about the Big Apple, so I took the Greyhound to Port Authority. That was seventeen years ago and I've been here since then.

I was looking for a place to stay that was not too expensive and people told me about the Bowery, so that's how I found out about the Providence. I've seen people come and go. I've seen the management turn over I don't know how many times. For me, it's reasonable. I'm unemployed and I'm single, and this is all I need: a bed and a shower and toilet. I'm happy with that.

Earlier years, I had problems with alcohol. Used to go on three- or four-day-straight binges, just drinking anything I could get my hands on. End up in a blackout or fight or court or jail. So now I cut down considerably. Nighttime, I go to Alcoholics Anonymous. As a matter of fact, six-thirty tonight I got a meeting.

I don't have no intentions of leaving the city. Not yet, anyways. I went back to the reservation a couple of times and I could only stay a week. There's nothing to do out there. This is where the action is. For the time being, I like Manhattan.

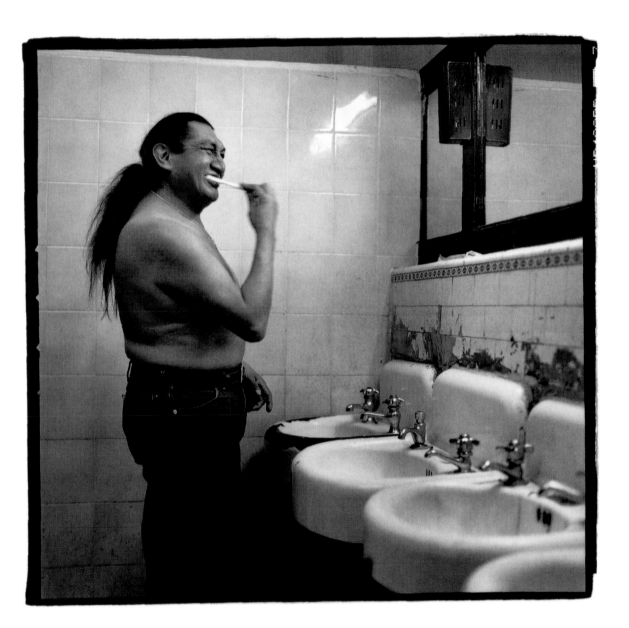

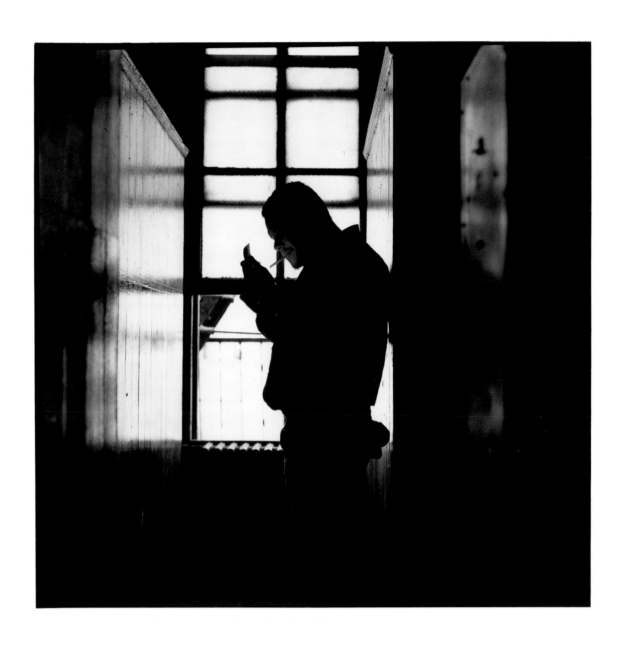

Ah yes—you must be Mr. David Isay from National Public Radio. Mr. Isay, I read the Sunshine Hotel piece in *The New York Times*. I hate to say it, but it seems to me you didn't really catch the flavor of the flophouses. Here's what you missed—and I think you have a chance to do it here—highly frustrated people.

All right, here's my story. See, I'm from Boston, and I was supposed to be a writer. The fact is that I had nothing to say to anybody. I had no message. I had an English teacher in high school who told me I had to write. She's a very successful mystery writer at this point, but she has nothing to say to people at all. Don't want to go into psychoanalysis here, but I don't see the point—why write if you have nothing to say?

Anyway, several years back, I had the misfortune of coming to New York. I could not get steady work, so I lived on the street for about nine months. Then I discovered the virtues of welfare and got into this place. That's it, you know?

Came here seven and a half years ago. Spent years going around with my résumé, and got rejected everywhere three hundred times—they're sick of seeing my résumé (in retrospect, I guess it was kind of sarcastic—you can have a copy of it if you'd like). So now I listen to NPR all day and read—the *Times*, *The New Yorker*, *The New York Observer*. If there's something to do, I don't drink. If I have nothing to do, I drink. That's what takes up most of my time. It's that simple.

This is the longest I've lived in any permanent residence since I was a child, so this is home. There's a sort of security here, and this is where my friends are. Actually, I don't need more space than this—this is exactly as much as I need. You want me to help you maybe find someone else to talk to? Anybody here is more interesting than me. Really. Trust me. I'm a bad interview.

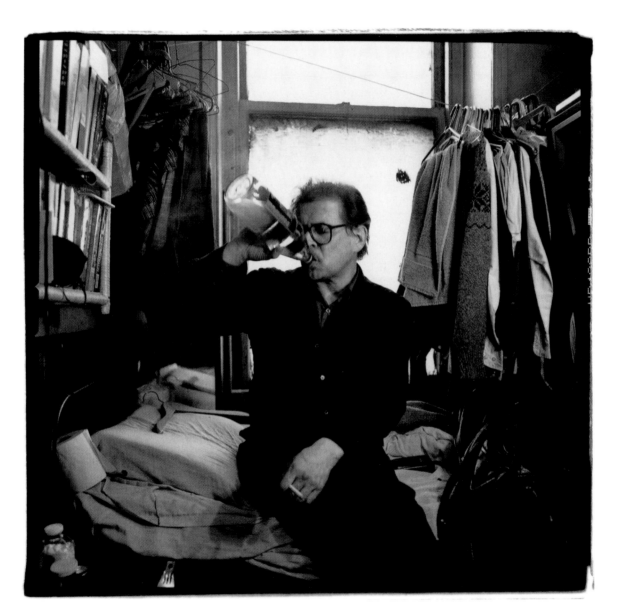

I'm from Cuba and I came to the States in 1980 on the boat lift. I came to this hotel because I was living with my mother-in-law and my wife. My addiction was starting to interfere with the rules that she got in the house, so I had to leave. I came right here because this is cheap hotel.

I love this country. You do whatever you want to do. You want to be a police, you're a police. You want to be a drug addict, you're a drug addict. Right now I want to use drugs. Maybe tomorrow I change it. But right now that's what I want to do with my life. That's why I'm right here.

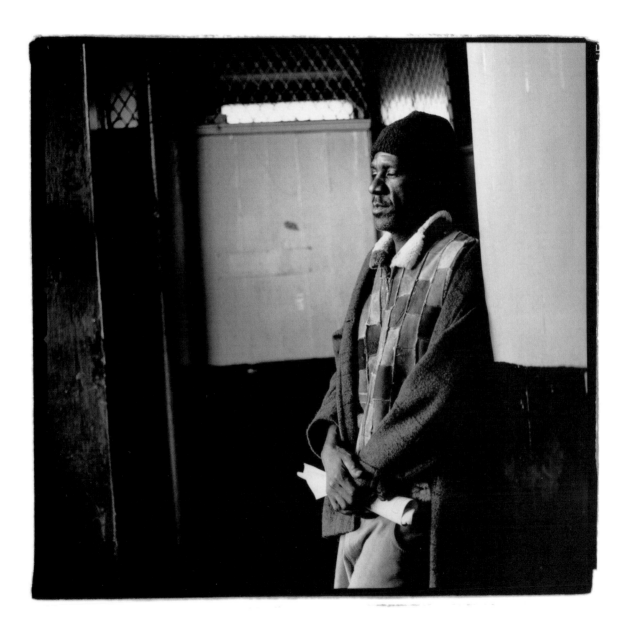

I rode my bike here from New Orleans a few months ago. I was looking for a cheap room, and I read about this place in a guidebook. It said something like, "Not for the faint of heart. Don't be surprised if you find yourself running out screaming." So I came down here not knowing what to expect, but it's worked out. You may have heard of "the power of the flop"—how people end up flopping around their beds all day. It's something you have to guard against. You gotta get up every day and get out of here. So I work during the days as a bike messenger and at night delivering pizza.

I've seen all types come through here. There was a Wesleyan graduate here awhile ago writing a book on China. There's also the guys here that aren't lucky enough to be institutionalized. There's the guys here who are smart enough to stay out of jail. And then there's the old guys who don't have the economic skills for the new economy. Upstairs you got these dealers going up and down the stairs all night long; it's like the levels of Dante's Hell. I tell the guys, "If you just put this much effort into a regular job, you'd be doing great, you know?" And you hear all kinds of things in here. I have this guy next to me rambling, "Fight the green monster!" all night. And Vietnam veterans flipping out. I tell people that if I could somehow stream what I hear here every day onto the Internet, it would be the greatest soap opera ever.

I call this place the Disfunction Junction, and the Fraternity House from Hell. But the Bowery is a vibrant community. Two blocks over, you're in Little Italy. Three more blocks, you're in SoHo. So I like the location. For a shower and a place to sleep, it's fine. If they'd just make the rooms about three times bigger and have Internet access, I think a lot of people would go for something like this.

I made a fatal mistake—I hit my wife. And when I hit her, she said, "That's it." And sure enough, that was it. She called the cops. A cop told me, "Look, I can't kick you out of the house—you're a legally married man. But I'm asking you as one man to another, I would appreciate it if you took a walk." So I did. And when I came back two days later, my wife was gone—took the kids and everything. I seen my wife on Nostrand Avenue. I got on my hands and knees and begged her to come back. I started crying in front of everybody. She just looked at me stone-cold, turned, and walked away. I knew it was over then. So it's hard, you know, when you love somebody and you don't have them no more. Especially when you know that you are the one that caused the breakup. She was a good woman.

After that, one thing led to another and I started snorting dope. I didn't want to have to sleep in the street, so to keep some type of dignity, I came here. I've been here a year and a half, stopped doing drugs, and established myself among the people that live here. And I feel comfortable. A lot of people in here do drugs, but I don't discriminate. Because I remember when I used to do that. And if there's something that I can say to them that's going to maybe help them turn their life around, I do it.

I came from a very wealthy family, and I had the best of everything. I went to private boarding schools, went skiing in Saint-Moritz. You name it, I had it. Grew up in a fifteen-room apartment overlooking Central Park West. Never had to do my own laundry—had a maid to do it. Had a country house with a pool. Went to college at the University of Denver. Lived in Aspen, Colorado, for twenty years and made a lot of money. Made a *lot* of money.

I smuggled . . . uh, marijuana—it doesn't matter at this point talking about this, 'cause it's already been over and done with and I've been prosecuted for it. I smuggled marijuana from South America in humongous amounts for, like, twenty years. Started off doing five hundred pounds and then, nineteen years later, we were doing seventy thousand pounds. Very successful.

I was doing quite well in life, and then I got busted by the Feds. I was very lucky, when I did get busted, to have the best lawyers, so I got a light sentence. It was before the RICO statutes went into effect—if it happened today, it would have been a lot different. Anyway, I had a falling-out with my family, and they disowned me. It was quite a blow to me psychologically. It just kinda knocked me over the edge. And I haven't been able to climb back up since. And pretty much in a nutshell that's how I ended up down here.

When I was on Rikers Island, I hooked up with this guy I knew in a bull pen, one of my crimees, and he told me about going to the Lower East Side. So I came down here from Washington Heights, and ever since then we've been partners. We stayed in the White House, the Grand, but I like this hotel the best 'cause there's people here I'm friends with. A lot of guys are crimees I know from Rikers. And it's more like a family structure. Believe it or not, we look out for each other. We hang out, we celebrate Christmas together, birthdays. If you're New Jack, it's rough. If you got people to back you up, nobody's gonna fuck with you.

Boosting [stealing], for me, is a natural high. You gotta have balls, but you gotta be a good actor, too. My long hair is good for the SoHo area, because I can pin it back and look like the rich white boy or the artistic white guy with long hair. It's a buddy system. My partner is Puerto Rican, and security guards are prejudiced. So he goes into a store and makes a pile of clothes. Security is watching him. I walk in with my aluminum bag. He walks by me and slam-dunks in twenty shirts worth two hundred dollars each. I walk out, and he's still in the store. If they think something's wrong, they walk up, check him out—and I'm long gone.

Jesus, we hit all the top-name stores. We used to get all the good stuff. But a couple of months ago he got shot. He and I done a job. My buddy was fencing some of the merchandise we had, and one of the guys around here didn't care for him for some reason and shot him. He almost died. Just got out of intensive care, and I think it changed his life. He got back with his family in New Jersey, and now he's going back to school, studying theater and acting. I'm real happy for him. If he tries to come back here, I'll kick him out.

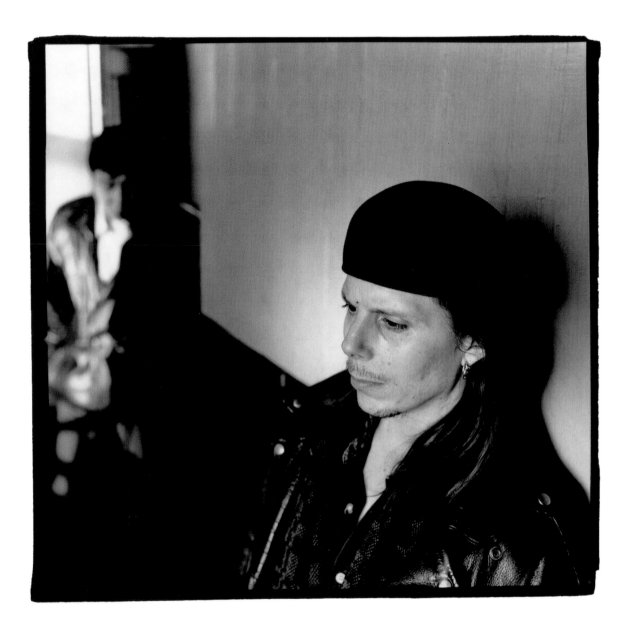

Dead of an overdose. Discovered April 2, 1999.

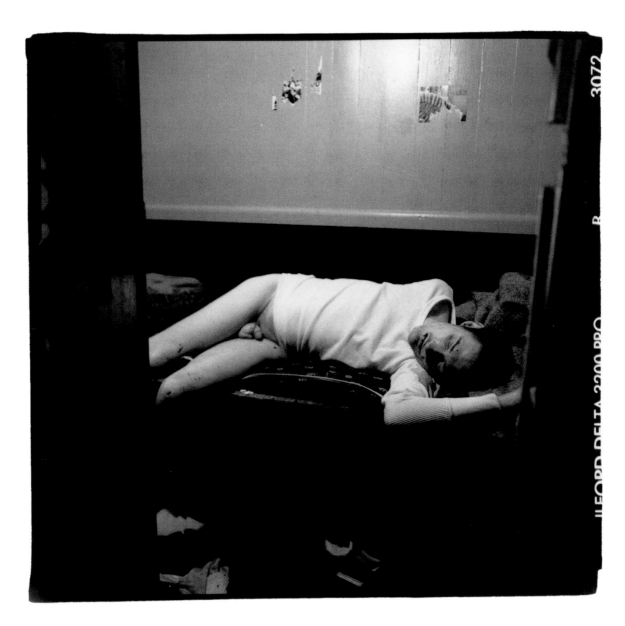

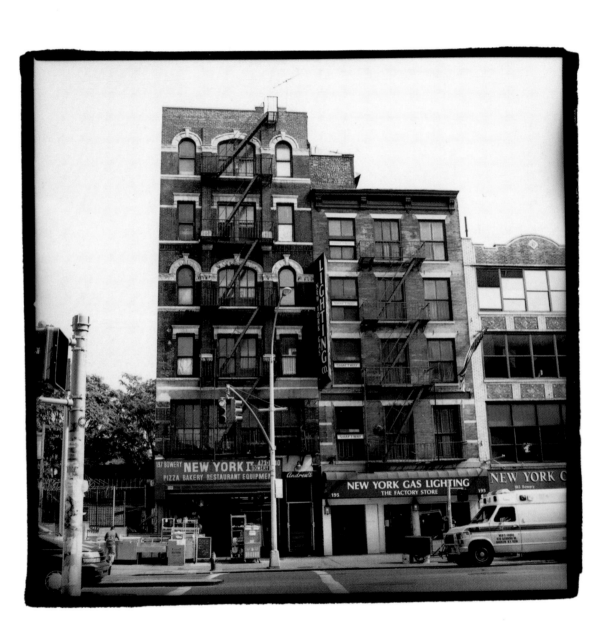

THE ANDREWS HOTEL

The five-story Andrews Hotel (originally the Montauk) was built in 1909 and today houses 183 men. It was purchased in the 1950s by the Gatto family (which, along with the Lyons Company, owned the bulk of the lodging houses on the Bowery at the time). It continues to be run by Mike Gatto. The Andrews offers the cheapest rooms on the strip—$4.50 a night—and is home to many of the surviving Bowery old-timers. The hotel has an eerie, frozen-in-time feel to it. Old men sit quietly in the lobby smoking cigars, reading the paper, and playing solitaire. Most don't want to talk. "I'm watching the news now, okay?" they say. "Maybe some other time." We weren't permitted to go back into the cubicles, so we did all of our interviews in the lobby. When we talked, men shot us dirty looks. Most of the residents who agreed to be interviewed wouldn't say much. The rest just wanted to be left alone.

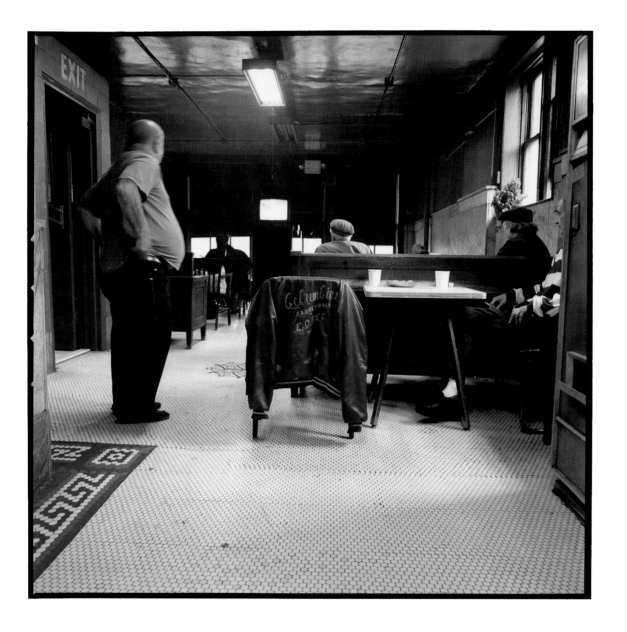

My grandfather was in the business in the twenties. My father went into the business in the thirties, and I was dragooned in '45. I was in the army in New Jersey, and my father called me and said, "Come on home. I need you." He had caught a partner of his stealing and kicked him out, so I started to run his places. There were four: the Lincoln, the Monroe, the Madison, and the Fulton. Those hotels don't exist anymore. Then he decided to buy me one for myself, and this is it. First of July, 1955. I been here since.

I turn a lot of people away. I don't want any aggravation with drugs and people who don't pay rent. A lot of hotels—I don't know if you've done many interviews—they're stuck with dozens and dozens of people like that. It's like a cancer. If a guy stops paying rent, you can't do anything about it. If you go to court, they postpone it ten times and never give an eviction. Never. Never. A man could start a fire in your hotel, and they still won't let you evict him. We pick and choose. I have a very nice bunch here. No real heartaches. Out of 137, maybe two or three I'd like to shoot.

A lot of people don't even know it exists anymore, the Bowery. People call up and say, "What's your address?" You say, "The Bowery," and they say, "What's that?" They have no conception. It's not like it was in the twenties and thirties—it was the biggest entertainment district in the whole city of New York! With all the hotels, bars, big burlesque theaters, girlie shows—I mean, it was quite a place! This is where they all came for their entertainment. It was also a great area for manpower. Fifty years ago, 90 percent of the people on this street were working for the railroads. It was mostly Irish and Slovaks—big drinkers and hard workers. That's what kept the whole street flourishing. But when the railroads stopped hiring help, that was the end of it. It just kept declining, declining, declining.

If I could close it up tomorrow morning, I would. Just about everybody else is out. Ten, fifteen years ago you could close a place and get away with it. Now, you can't leave unless you find a Chinaman to buy you out. If we could close legally, I think every one of us would close up. Instantly.

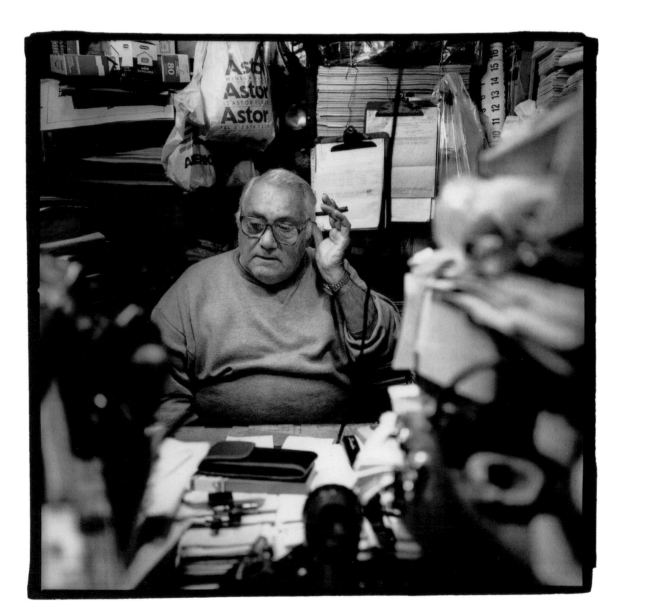

I'm from Harrisburg, Pennsylvania. Came here in 1948, after my father passed away. I was eighteen when I come down to the Bowery. I'm sixty-eight years old now. When I come down here, there was flophouses all along the Bowery. All these buildings down here was flophouses years ago. But no more. Why'd they close 'em down? Because the Chinese wanted the people out, that's why! It used to be a lot of white people out here—Italians, Jewish, Irish. Now it's just Chinamen. They bought everything on the Bowery!

On one block down here, you had one, two, three, four bars on one side of the street. Now you got nothing here—no bars at all! Where's a guy supposed to go to get a drink? Nowhere! And you had tattoo parlors down here. This is a Bowery tattoo, 1948. Them days, baby, it was a good Bowery! You could go down here on the corner to the restaurant and get you two pork chops, mashed potatoes, gravy, corn, and coffee for two dollars. Where are you gonna get that on the Bowery now? Nowhere!

I started drinking when I was ten years old. I had everything when I was ten years old, baby. Whiskey, wine, beer, Sterno that you heat up food with. I did everything. For many years. But I don't drink no more. I said, "No more for me!" I quit altogether. Did it cold turkey. Didn't go to AA meetings, no. Didn't go to alcoholic people for help or nothing, no. You want to do it, you just do it—that's all!

I been here too many years. I'm going back home to Harrisburg pretty soon. Come July, I won't be on this Bowery, baby. I'm tellin' you right now, I won't be on this Bowery at all!

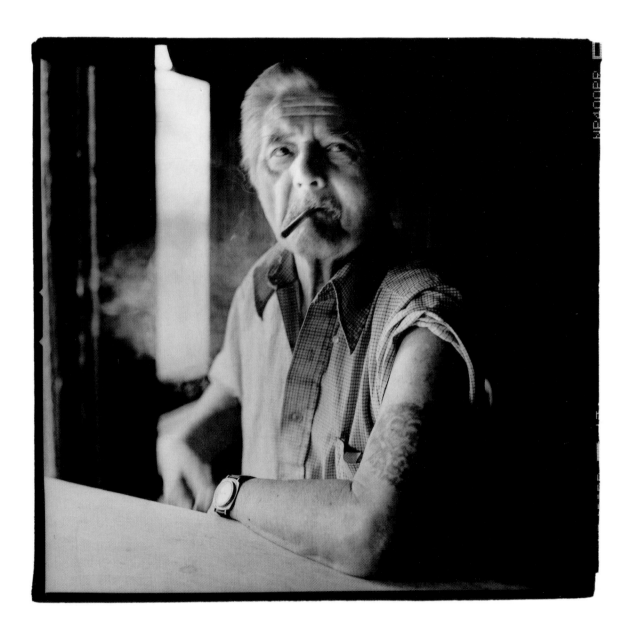

worked as a toolmaker on Long Island. Ended up on the Bowery when I got divorced from the wife. The Palmer, the Essex, the Comet. A week here, a week there, two weeks here, a year there. That's what's been going on for thirty years. Now I'm seventy-eight. Got a short life left. As far as convenience goes, this is all I need—a nice little bed, a place to sleep. Don't talk to people—always been a loner. Been drinking all my life, but I'm sick now and I can't. Wish I could.

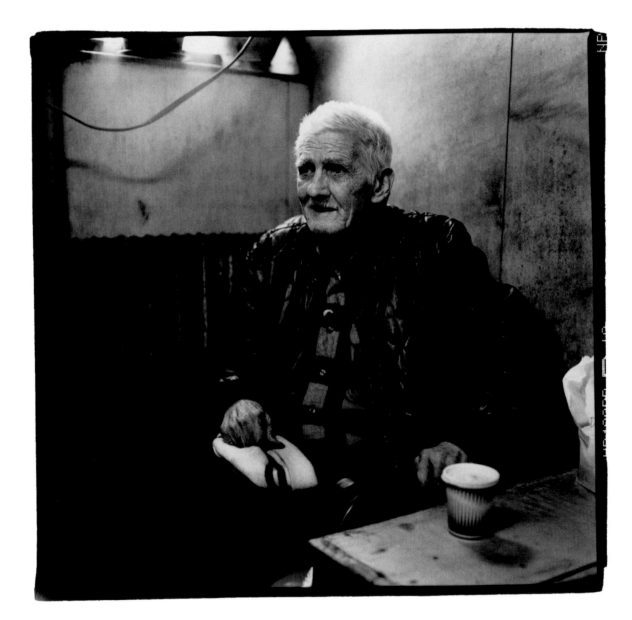

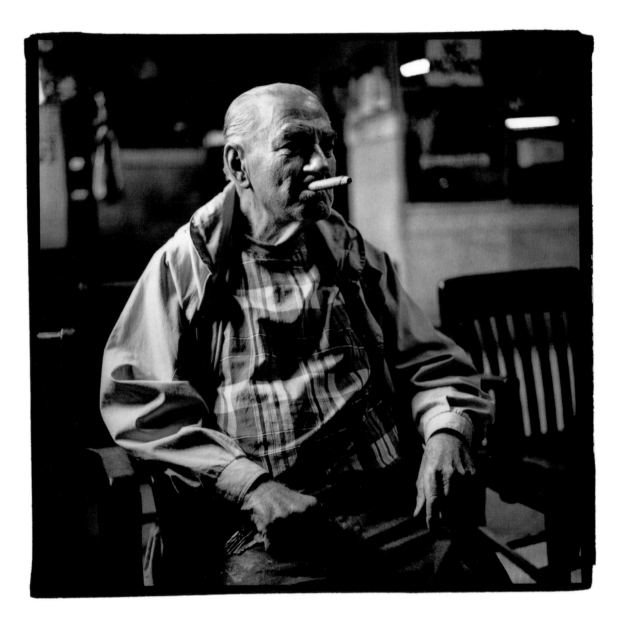

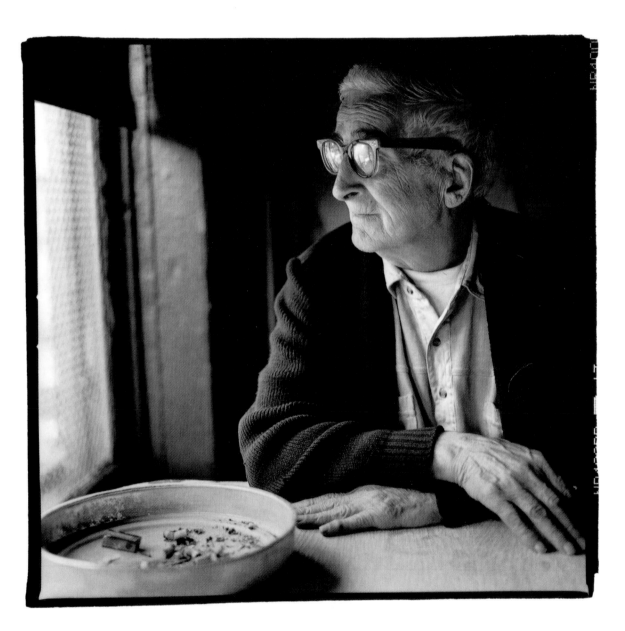

I was born April 25, 1918. An interesting thing is that Ella Fitzgerald and I were born on the same day and the same year. Of course, she already passed away—somehow I manage to live longer than other people. I was a drinker for a long time. I counted 136 men who died that I drank with up until I moved in. Since then I counted eighteen more.

Came here four years ago. I was living on the streets for many years. Met a fellow at the Port of Authority and asked him where he'd been. He told me about this place, and I came down. It's the best hotel because it's the cheapest and, at the same time, the cleanest of all of them.

I separated from my wife in 1950. Left her with two daughters. One day after I moved here, I wrote to my wife and said I'd like to see how my daughters grew up. My oldest daughter saw the return address. So one day I had a knock on the door from the clerk stating that my daughter was downstairs. I hadn't seen her in thirty-nine years. That was on October 29, three years ago. Since that time we've been very close. It's because of her that I quit drinking. My daughter and her husband run a dry house. When I first went there, I'd say, "Would you go get me a 'cousin'?"—which was a bottle. And she'd go out and get it for me. After a while I got kind of embarrassed. Lonely drinking is no good. So I just stopped altogether. That was eighteen months ago. In the beginning, I used to have an antidote for drinking which a lot of people don't know—I'd eat a peanut butter sandwich. But now my desire for it is gone. I have no care for alcohol now.

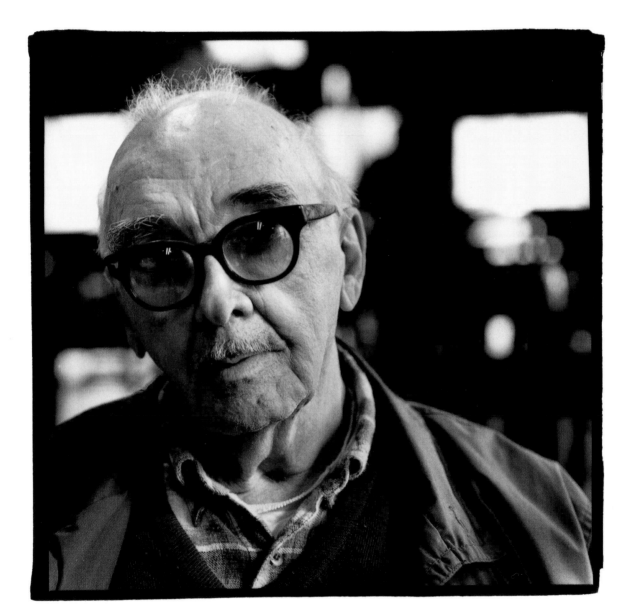

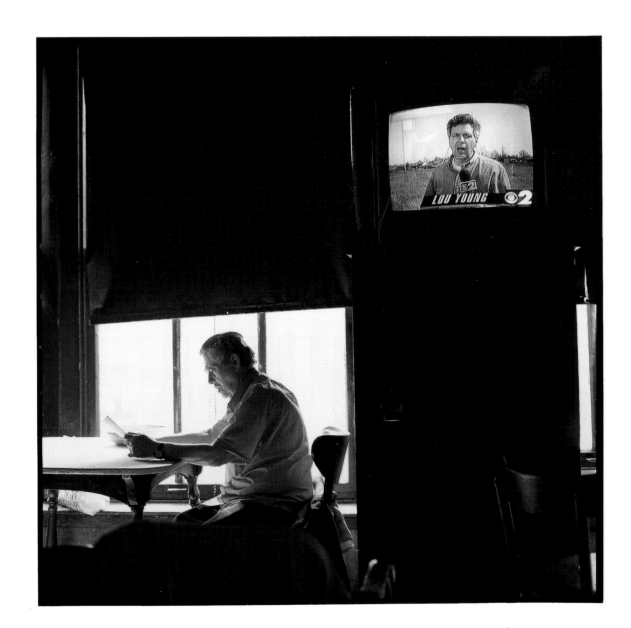

I'm fifty-three and proud of it. I'm a strong fifty-three-year-old, and I enjoy my life. I'm from New Zealand. A woodworker. And I don't mean this as a boast at all, but I'm known as a bloody good woodworker.

Came to Andrews 'cause I was hungry. And drunk. It's a place to sleep, take a shower, shave now and again, get up in the morning and work. I enjoy my work. I'm fortunate that I'm not sitting in front of a computer or a steering wheel—I have a hammer and chisel and know how to use them. I need not say more.

I'm not a good manager of my life, as simple as that. When I'm not working, I tend to drink what I earned the previous week. I enjoy myself and just go to hell with it. But as Edith Piaf said, *"Je ne regrette rien"*—I regret nothing.

There's a certain politeness to this hotel. For instance, the passageways on the floors are narrow, so if there's somebody coming this way and you're going that way, you step aside and wait. There's a certain etiquette. And I like that. I feel for these old men. They're just fellows waiting to die. I'll cook for them or read them a story. If they want a pack of cigarettes, I'll go get it. I don't feel that I should just let them dissipate. Got to give them a bit of humor, put a laugh in their lives. They tend to dwell on the past. I don't. I dismiss my past and live in tomorrow.

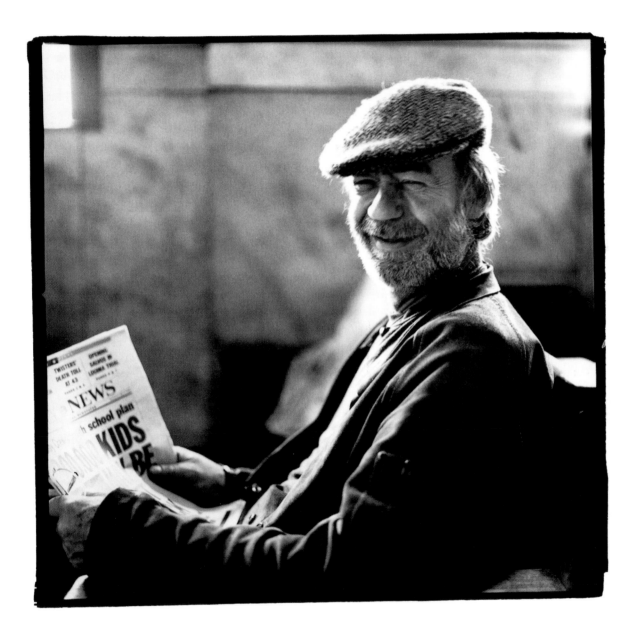

When my wife passed away I lost everything. We were married a long time and it hurt— you could shoot me and it'd be less painful! So I sell the house and drift around. Take a lot of trips—to the coast, to Vegas. Eventually the money goes, and I'm still drifting. Came down here fifteen years ago. I lived for a lot of years across the street at the Prince. But here the rent is cheaper, it's cleaner, and I've found that the people are better. Less drinkers. It made sense for me to move over here, so I did.

It was a romance story you could put on TV. I met her at a dance. Beautiful. I was with my brother, and I said, "Look at that gorgeous woman! I'm gonna marry her!" He says, "You're crazy!" So I talked to her a little bit and then I said, "Will you marry me?" She says, "Sure." And that was it. Six days, blood tests, and we're married. Six days! I was taken apart by both ends of the family. "It'll never last!" "It's just physical attraction!" And it didn't last. Not much. Just thirty-three years.

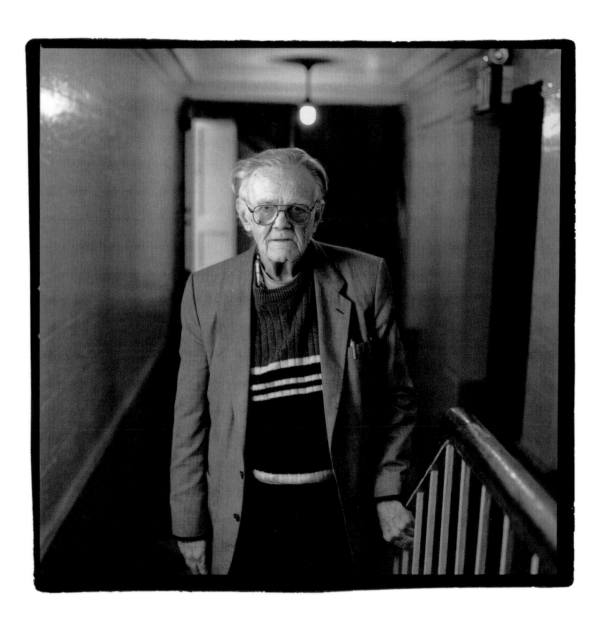

Years ago, I had a nervous breakdown. I was in a hospital recuperating, and it was there I got interested in art. I left and came down here and just kept going with the painting. That was in 1952. I been here a long time.

This picture is called *Mickey Mouse Mayor.* I made it when Giuliani got elected. He was a prosecutor before that and put a lot of people in jail. He had a lot of enemies, and they called him the Mickey Mouse Mayor. I thought it was appropriate at the time.

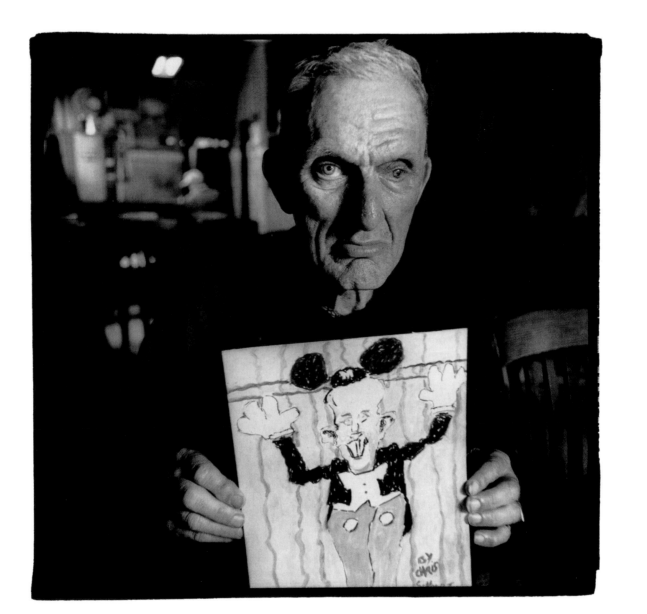

Let me tell you my story—this is going to fascinate you! When I was six months old, my mom took off on my father. My father couldn't handle me, so he made me a ward of the city. They placed me in the Hebrew Orphan Asylum—I'm a Greek Jew, see?

So I was about nine years old. One day, one of my friends comes over to me and says, "Jack, there's a lady to see you." A lady to see me? And there's a woman leaning against the wall. I go over to her—don't know her from beans. So I says, "You looking for me?" She says, "What's your name?" I says, "Jack." She says, "Kiss me—I'm your mother!" I run away. I

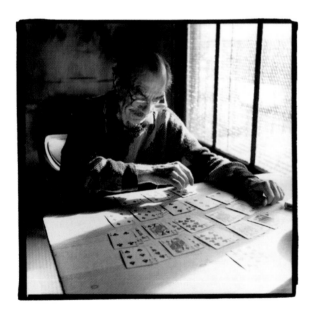

mean, it shocked me—because my father told me that she was dead!

When I reach sixteen years old, my mother comes back—this is going to fascinate you—and says she wants to take me away. And I tell her, "No, I don't want to leave." "But, Jack, you're sixteen years old . . ." And she persuades me to go. My mother tells me she'll take me to Baltimore, where she's got a candy store, and I'll take care of the candy store. So I agree. I sign myself out of the home—which is the worst thing I ever did in my life. I get to Baltimore, no candy store. In the morning, my mother goes out and puts me in the street. I'm waiting on a stoop for her to come home. It's now eight o'clock at night. Nothing to eat. I start to cry. Run away and come back to New York.

Pretty soon I enlist in the service. This was 1943. I was seventeen years old. I land on Okinawa. First mail call, they had bags and bags of mail for the guys. They were calling out names and I was just standing there waiting. I stood there for two hours. No mail. They kept calling and I waited. Finally they finished, and I says, "I ain't got no mail." I ran up into the hills and cried. [*Starts to cry.*] Excuse me. [*Walks away.*]

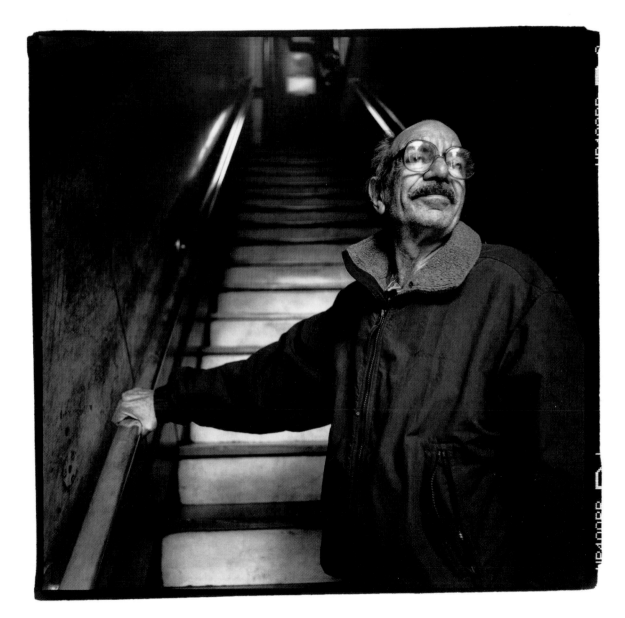

was born in Paris, Tennessee. Small town. Farming country. No education—just the first and second grade. Come up north when I was twenty-one years old. Worked in the country clubs in the Pocono Mountains in the summertime. In the winter, I was here.

It's a good hotel, good hotel. 'Cause it's quiet. Sometimes some of them might drink too much, but if they do, they go to bed anyway. It's quiet. I like a quiet place. As far as I know, there's no need for me to go back to Tennessee. Gonna be here the rest of my life, as far as I know. I'm completely satisfied.

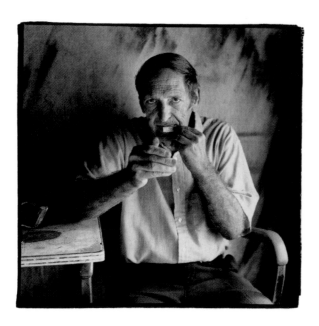 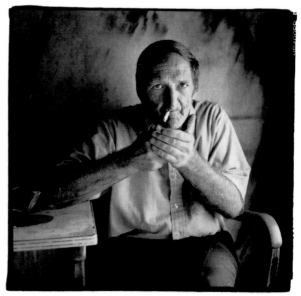

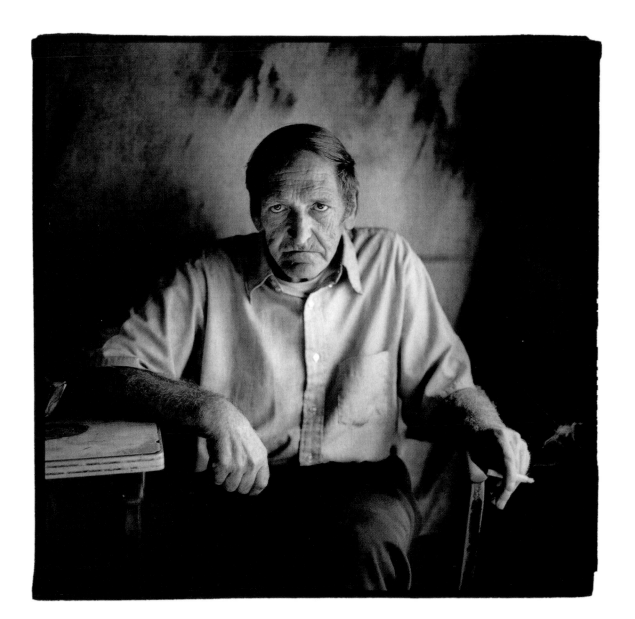

I was an orphan all my life, see. My parents died when I was a baby. My father was a tugboat captain, see, and my mother was a house-maker. He must have known a lot about the sea, because he was from Denmark. My mother came from Sweden.

I came down here in '41. I was twenty. I was here before Mike Gatto got here, see. His father gave him this place for a present. I been here the longest of all—I should be the owner by now!

It was a different class of people back then, see. One guy was a painter, another guy a cook, another guy worked in a bar. I worked for a moving outfit. I'd be sitting right here and the guy'd pull up out there at seven in the morning and right away I'd run out and go to work. You walked into the lobby during the day and it was empty—all the people were working. You didn't see nobody sitting around.

I had a common-law wife, Helen. I met her in a bar, see. Sometimes she treated me nice, sometimes she treated me lousy. Sometimes she'd bring me bananas. Sometimes she'd yell at me, scream at me, take my money. She drank all day—whiskey—any goddamn thing you give her. She was thinking I was going to die before her, but she went before I did. Her daughter from Queens came down here and told me her mother passed. Then she said, "I don't blame you for not going to her funeral." The daughter knew she'd been using me, cheating on me all the time.

There's very few old-timers left. Most of 'em passed away. I don't know what I'm going to do now. What can I do? I was twenty when I came here. Now I'm eighty-one. My mind is all mixed-up. Don't know what else to tell you.

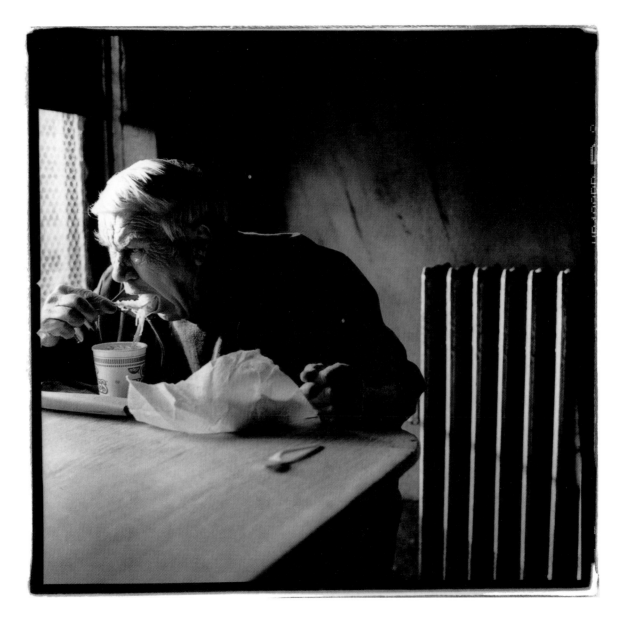

Everyone in this place is hiding. Not from the law, but from people. They're hiding from wives or they're hiding from girlfriends, or from people they owe money to. They're escaping and don't want nobody to know where they are. Like me—I'm escaping from my second wife. I don't want nobody to know where I am. I don't want to be found. I'm sixty-five years old and I just want to live out my life. Quietly.

Eddie asked not to be photographed.

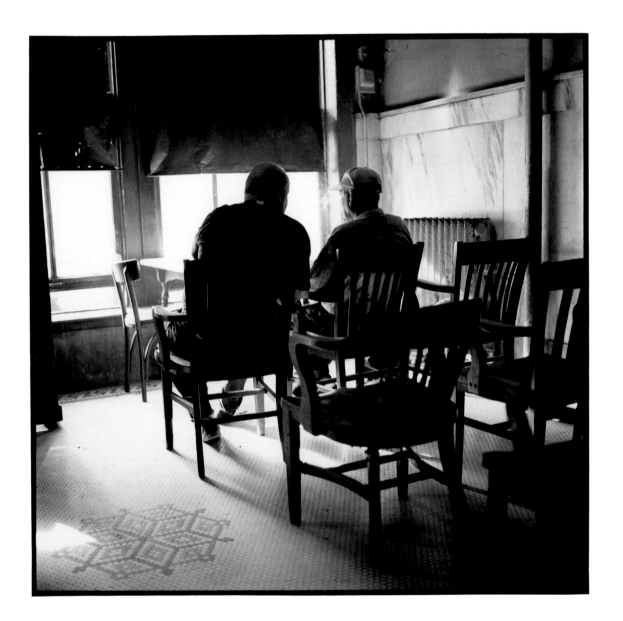

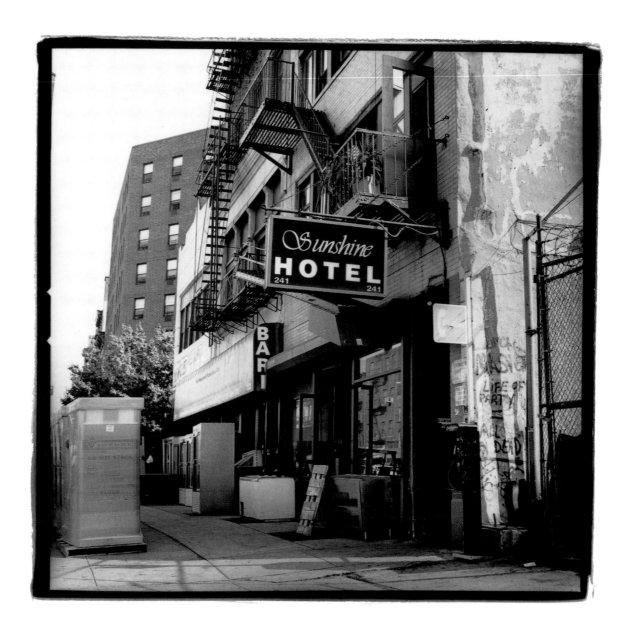

THE SUNSHINE HOTEL

The Sunshine was opened in the early 1920s in a former pickle factory by Frank Mazzara, a broom-maker, who followed his brother-in-law, Mike Gatto (father of the Andrews's Mike Gatto), into the lodging-house business. Mazzara's son, Carl, took over the business in 1946 and ran it until his retirement in 1984. Mazzara sold the hotel to his ground-floor tenants, the owners of a used-pizza-equipment store, who took it over so they wouldn't have to move their inventory of used pizza ovens. "I enjoyed my life on the Bowery," Mazzara remembers, from his home in Queens. "I would always take care of my men. Many of these guys had families that didn't care for them. When a guy died, I'd deal with the undertaker. When they got sick, I'd visit them in the hospital. It was always an interesting place to be." Today, the Sunshine is home to 125 men, who sleep in cubicles or in one of the hotel's three barracks-like dormitories. The Sunshine is the last hotel on the Bowery offering this type of accommodation. Under the laissez-faire watch of manager Nate Smith, it is the most raucus of all of the remaining flops. The hotel teems with characters, and often feels on the brink of chaos.

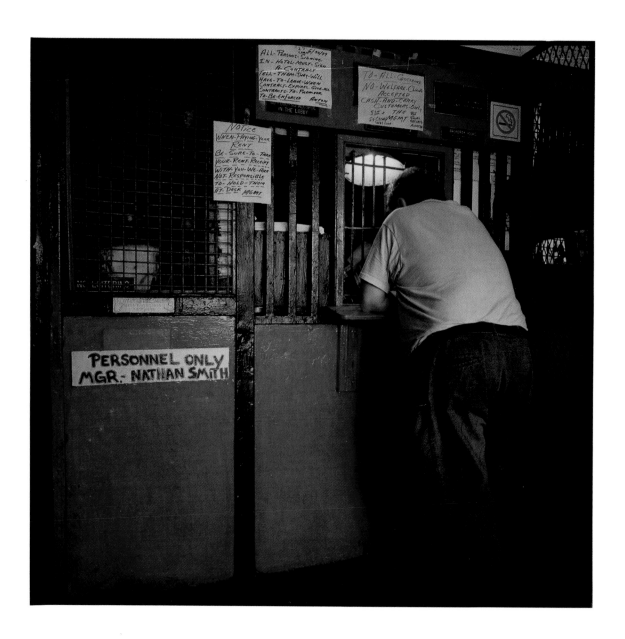

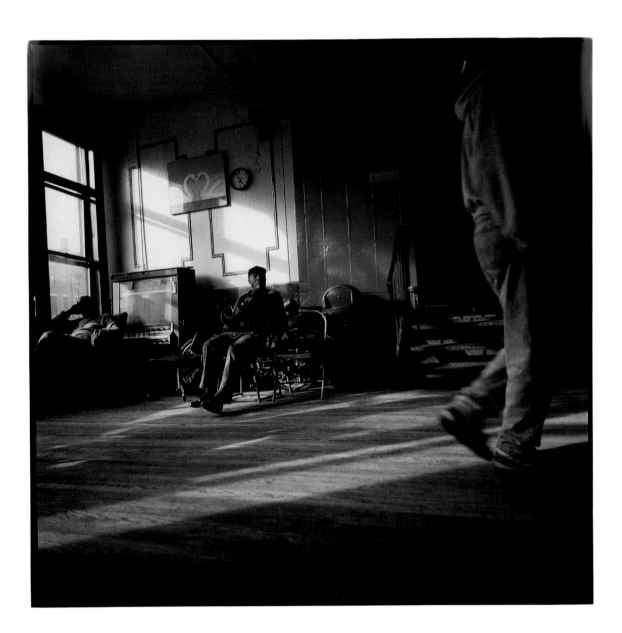

I came to the Bowery some years ago. I was an ordinary family man working for National Westminster Bank on Wall Street. I lost my job and my wife walked out, so I ended up down here. Been manager about twelve years. Last manager was a Swedish guy, Ole Olson. One day he put a gun in his mouth and—*BOOM*—blew his brains out. Had to wipe the bloodstains off the walls. Shot himself in that bed right there—the very same bed I happen to sleep in today!

This is an "eat it and beat it" hotel—people are supposed to come and stay for a day or two and get out. But for some reason, people like to stay—for *years*. We don't have any amenities here at all—no soap, no towels, no TVs, no maid service. The only thing you get is a lightbulb and a locker. The Waldorf-Astoria we're not. But it beats living in the streets.

When I first came on the Bowery, we used to get doctors, lawyers, engineers—the whole nine yards. They had a streak of bad luck, or the wife left or the wife died, and they ended up here. It was the cheapest place you could stay. Mostly alcoholics then, mostly Caucasian. But over a period of time, the demographics shifted and they were replaced by the younger kids and the drug addicts we've got now.

I've had 'em all here—from a priest to a murderer. We've had two Jesus Christs since I've been at the Sunshine—long white beard, robe, sandals, the whole nine yards. One of them used to live right there in 2A. He was so entrenched in his Jesus thing that he used to feed the mice, the roaches, the rats—everything. Finally I had to throw him out. "Jesus, you're a nice guy," I told him, "but, Jesus, I got to put you out, buddy. You're making a health hazard here!"

My most famous tenant was the cannibal Daniel Rakowitz. Very nice guy. A little weird. He lived right there. One day I knocked on his door and I saw he had a cage with twenty-seven gerbils. I said, "Rack baby"—that's what I called him—I said, "Rack baby, this is not gonna work. Me and you are good friends, buddy, but you're going to have to leave." Next thing I know, he's serving a girl in a stew to the homeless in Tompkins Square Park. But he was a down dude—a very nice guy. Listen, they can be murderers or whatever, they're all right with me. We've always had different people here. Different people go with the territory.

MASSA: You know how a cat's got nine lives? Well, this guy, he's got *eighteen* lives! I'm telling you!

BUCHALEW: I don't like talking about the past too much. There have been good times and bad times, you know? I've been a night watchman, a moving man, a switchboard operator . . .

MASSA: He's very good with his hands. He can fix the TV. Me, I'm all thumbs. I drop things.

BUCHALEW: That's 'cause you don't put your mind to it. You just got to try a little harder sometimes, that's all.

MASSA: We met in a shelter in New Jersey about five years ago. I lost my father to cancer. Next, my mother had brain cancer. And then my brother died, also from cancer—it wiped my whole family out. So I just went off the deep end and started shooting cocaine and all this other shit. I lost my job, lost my apartment. So I'm in this shelter and I see Mike sitting there and I say, "Do you want a cigarette, buddy?" And he says, "Yeah." And then we started talking. Michael told me about this place, and I said, "Let's go!" That was five years ago. Still haven't started looking for a job. One of my bad traits is lazy. Very lazy. So I just watch a lot of TV—I'm a TV addict . . .

BUCHALEW: I'd rather listen to music. I'm used to working most of my life, so it's boring sitting around here.

MASSA: Very boring . . .

BUCHALEW: I try to keep my mind occupied by reading a lot.

MASSA: He likes Stephen King.

BUCHALEW: A lot of different authors.

MASSA: We're very different. I don't like to talk that much; he likes to talk. I'm not a morning person; he is always up early. Michael's very neat. I throw everything everywhere. We yell at each other sometimes . . .

BUCHALEW: . . . Why try to hide your feelings?

MASSA: You can't hold them in.

BUCHALEW: Lately, my health has been going downhill. I was hit by an automobile, and sometimes during the day I'm in immense pain.

MASSA: It's true. And because he's on methadone, the strongest painkiller they'll give him is Motrin. We're both on methadone. We're what they call "lifers"—we'll probably be on it for the rest of our lives. It's just luck that we're both alive.

BUCHALEW: I was born and raised Catholic, and I believe in the good Lord and hope that one day things will work out better than the way they've been going. I hope that we do better, because we *can* do better.

MASSA: Amen to that.

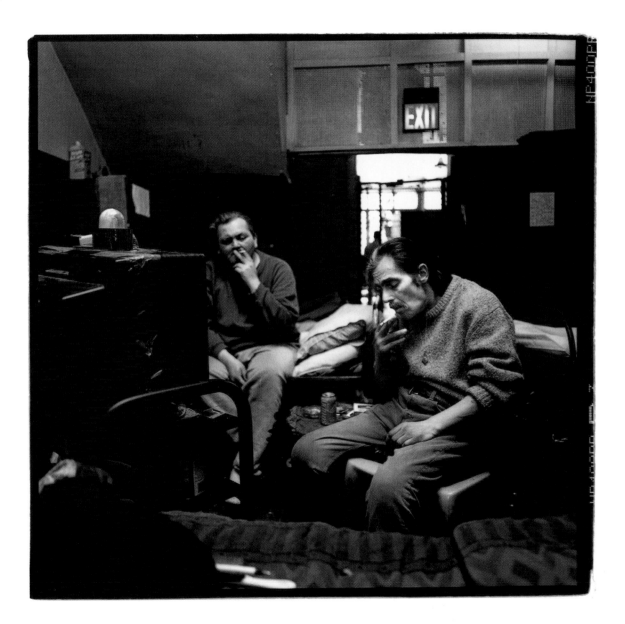

When I was a baby, I had a head injury. Fell down marble steps. The white steps turned red, if you get my drift. My cousin Josephine, God bless her if she's still alive, she clutched her hands together and squeezed. She held me in a vise grip and kept my brains from falling out. The doctors put me back together, but from that time on, I got a slow learning processing. I lost my mother when I was four. My father couldn't hardly take care of himself, so the courts took me away and made me a ward of the state. Came down to the Bowery when I was nineteen.

When I first came to the Bowery, I was a normal-

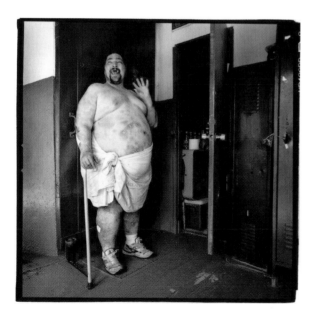

sized person, but then I started putting on weight because of self-esteem. Now I have a little bit of a weight problem. It would never seem like I'm 425 pounds, but I am. Sometimes I knock off a 26-ounce can of Chef Boyardee ravioli. That's for five people in the family—and I'll be eating it cold, right out of the can. That is a load of eats!

I stay in my room a lot, and I sleep practically all the time. I can't go nowhere, because I ain't got no clothes. See that pair of pants? It's been hanging there for two years. Don't fit. So I wear an old sheet that looks like a toga. I'm pretty comfortable in my sheet. I live with it.

I don't want to leave this place. Not yet. It's too much like home. You been in a place such a long time, people get to be like family. Like Nathan—he's a father to me. And who would leave their father when he's getting a little older? I been on the Bowery twenty years now. I'm what you call one of the "survivors" down here.

Anthony Coppola died on August 7, 1999.

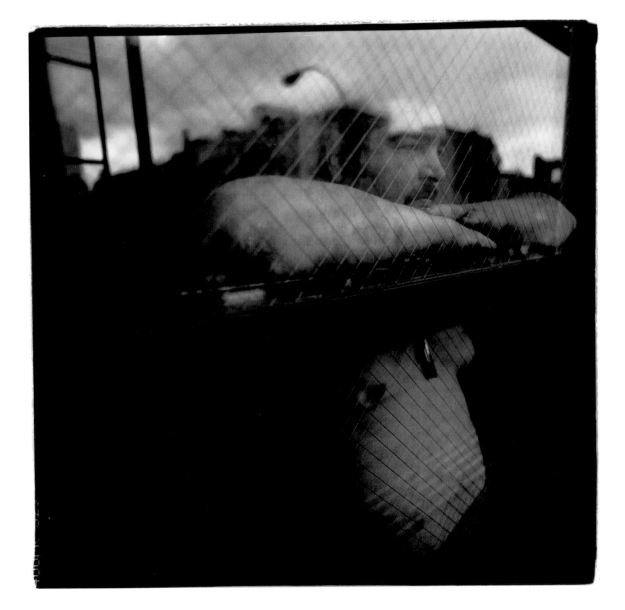

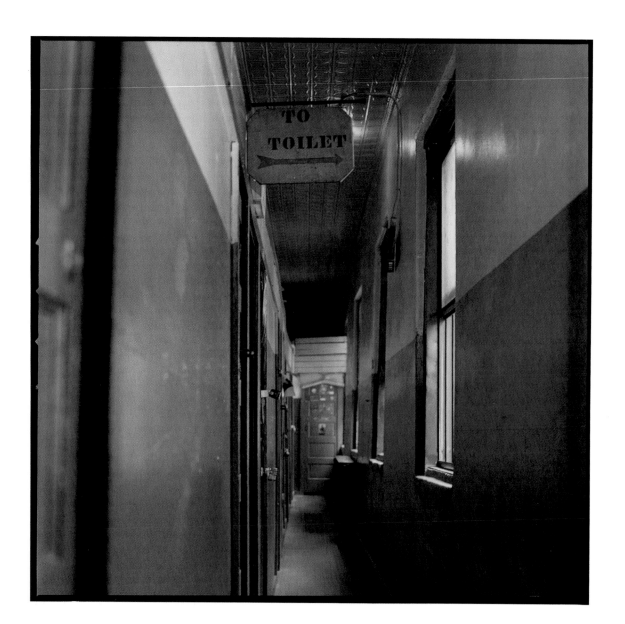

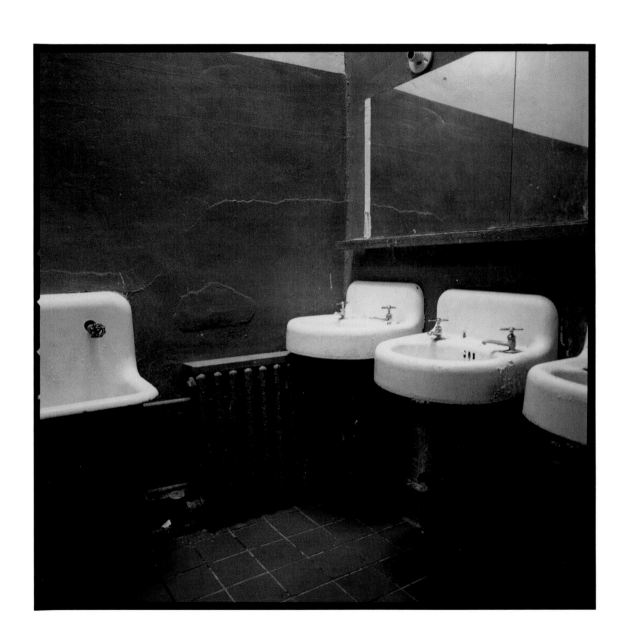

My girl name is Cashmere and my boy name is Timmie Vassor. I'm thirty-three, I'm a transsexual, and I've been living in Sunshine going on four years. I grew up in Harlem. Always looked like a girl and always had feminine ways. At home I couldn't wear dresses, and when I wore boys' clothes I still looked like a girl. My parents didn't approve, so I left home at a very young age. And when I left, it was a very fast life and it was a very hard life for me.

At first I stayed out in the streets, homeless, prostituting for money and food. After a while, I went to live with this queen named Alexis in Flushing, but I ended up on drugs. She tried to put me in drug programs, but I didn't go—I didn't care about anything. She got sick and tired of me and recommended me to the Sunshine. I been here ever since then.

I go to the Mission and the other little churches around here every day and ask God to forgive me for all my sins. He gets very angry with me 'cause I dress like this. So I just get on my knees and pray: "Lord, steer me in the right path, Lord. Don't let me go back to the streets, Lord."

I've did everything to transform me into a woman—the only thing I haven't had is a sex change. I've had breast implants. I've had nose surgery two times. I've had my cheeks done and my hips done and my eyes pinched and my skin bleached. All my male hormones are gone, and I take medication to keep me feminine. It's probably too late for God to change me back into a man, but I'm still hoping to get saved and change my life. I don't want to die and go to hell.

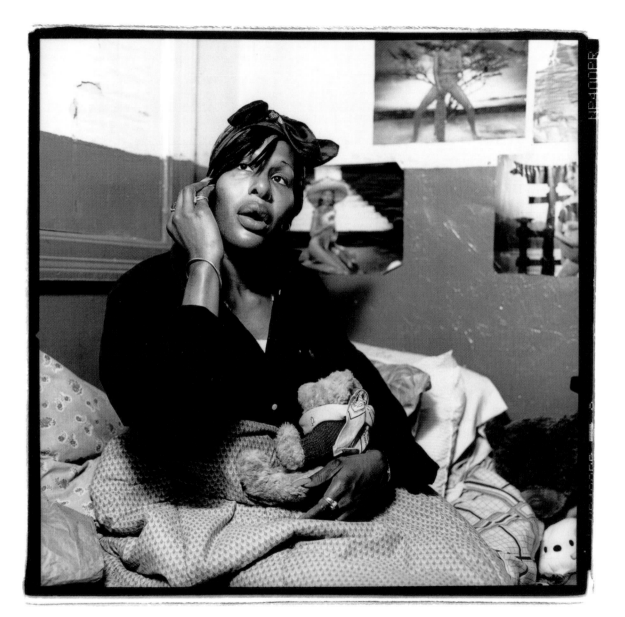

When I came to New York, I was on the run. I was wanted on a warrant in another state, and I came here to live because I heard they had a little refuge. They did. I moved into the Sunshine, and after a few days of just sitting around watching the old runners* botch job after job, I said, "Hell, I could do that!" I did a couple of runs. Guys liked me, so I picked up a couple more. Then I kind of settled into it. It's been eight years now. Don't charge much, but I deliver a lot.

Running is serious business. First of all, you have to realize you're handling other people's money in the middle of the hustlers' capital of the planet. It takes constant concentration and constant alertness. The main thing is do the steps: 1) remember your order; 2) remember who gave you the money; 3) remember how much they gave you.

And, walking all the time, you've got people constantly distracting you—distraction's your biggest enemy. You've got to keep the order going around in your mind the whole time. It's a work of constant concentration, constant alertness. No cobwebs. You've got to do the mental work!

And very dangerous. A war zone. You run into every kind of person that's out for money in the world out there. You got to constantly be on guard. Always ready to defend the money—mentally and physically. You got other people's money on you—you got to defend it better than you would your own, because that's your livelihood.

I see this as the beginning level of the high-intensity financial life of New York City. I have eight years here. Earn about twenty dollars a day. Totally honest reputation. My reputation is my business. No mistakes allowed. You blow it once, you could ruin your career. I don't blow it. I don't blow it!

* Every Bowery flop has "runners," who run errands for other residents for one-dollar tips.

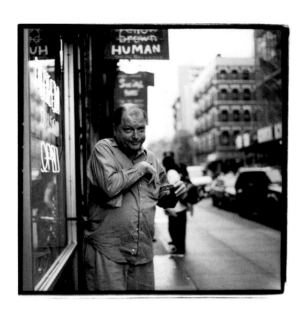
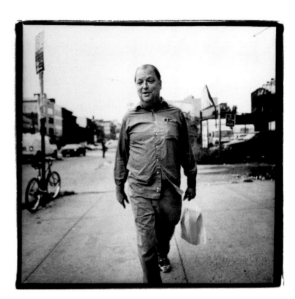
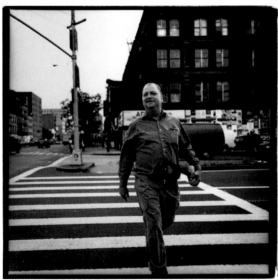
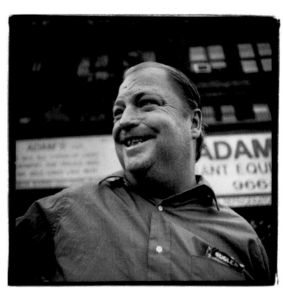

This is a roof over my head. I live within my means. You never live above your means. I mind my own business. I stay by myself. I don't bother anybody, and nobody bothers me. If they say, "Hello," I say, "Hello." If not, I go about my business. It's a roof over my head.

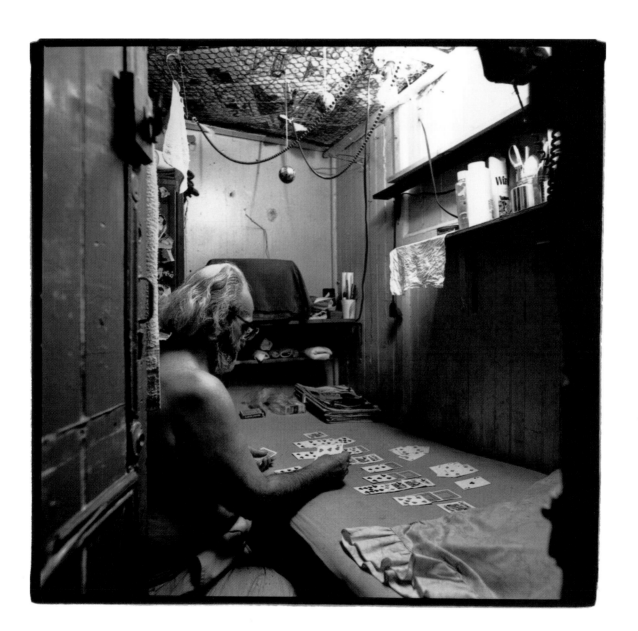

'm forty-eight. In fact, I'm forty-eight today. Yeah, happy birthday to the old black sheep of the family. My family would die if they knew I was here. I'm from Boston, Massachusetts. Lace-curtain Irish. Proper Bostonians. White-picket fences—that ain't my bag. I just couldn't deal with that kind of stuff. I was different.

I was a traveler. A partier. I was working at a transvestite boutique for a while right up here on Fourteenth Street. It was mind-boggling—guys would come in and buy wigs, bras, corsets, padded butts. There was one person I met—I won't even tell you his name—who was an undercover narcotics cop. I helped him with his makeup. He looked fantastic—like his twin sister would look. We went out for six months—I'm bisexual, by the way, if you haven't figured it out yet. Every time I see the undercover cars go by here, I think, Oh my God, what if he raids this place?

When I was back in Massachusetts, I was dating a guy. My brothers and sisters didn't want me to tell my mother. Too late—I already did. I wasn't going to keep secrets from her. She said, "As long as you're happy, that's all I care." My mother was my best buddy. I'd spend every Saturday night with her, making dinner. That's where I learned how to cook. We were confidants. She died on April 29, 1992. She was the only one that I wasn't the black sheep to.

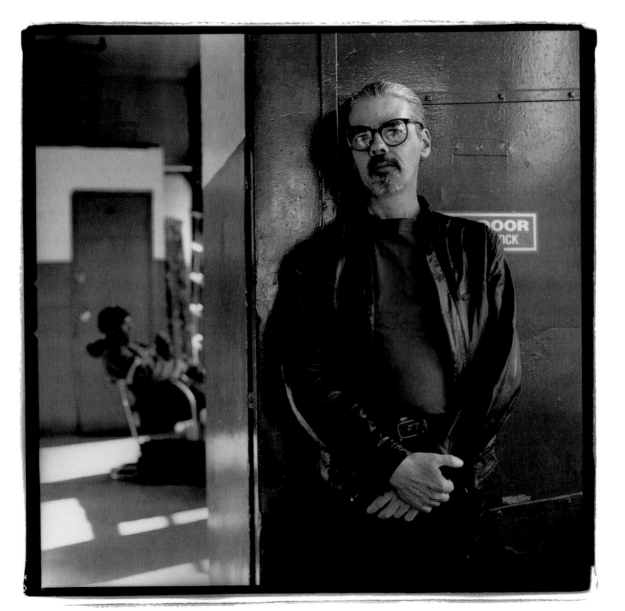

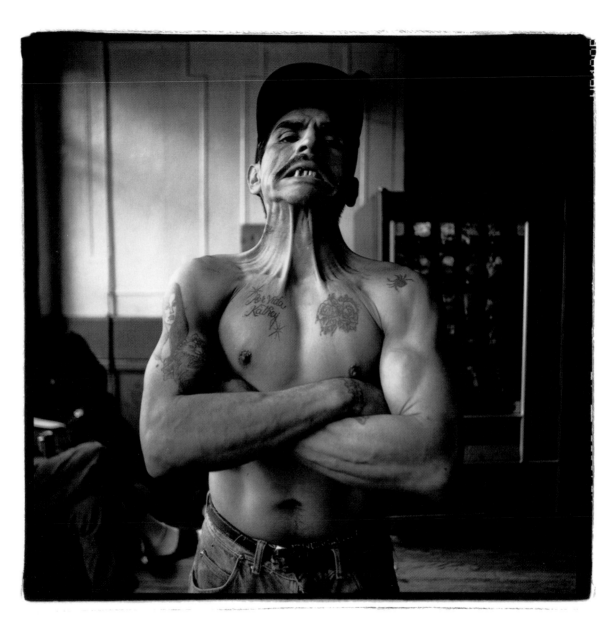

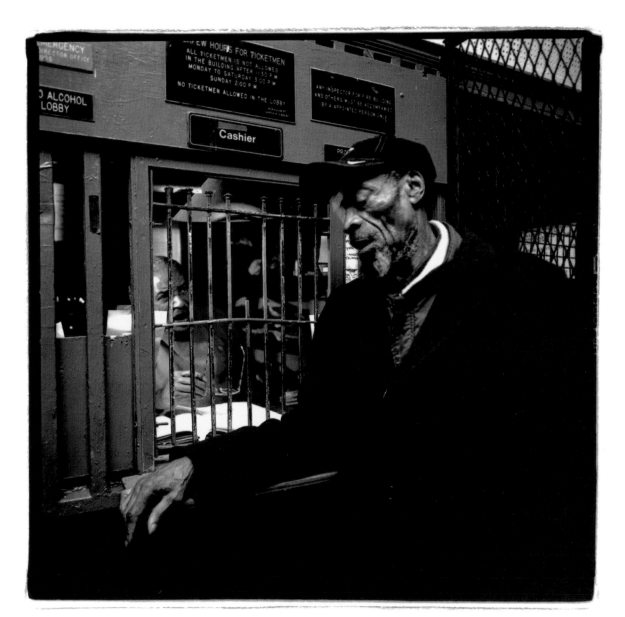

When I first got here, this hotel was a mess. I was brought up in the South, in a nice home with parents, and I've always cleaned up after myself. So when I saw how dirty this place was, I just started cleaning. Started sweeping the floors and changing the trash. Repainting. I was working twelve hours a day. Finally they gave me a job. It ain't no real job—I don't even make minimum wage—but I enjoy the work. I like to clean.

I start in at eight o'clock in the morning and stop at midnight, just working and cleaning. Scrubbing the walls, cleaning the windows, sweeping. I hate to see dirtiness, and I have to keep busy. If I'm not doing something, I get depressed. It's like I'm in a house with 150 children and I'm just steady walking around picking up after them. The guys that sit in the lobby drinking beer and smoking leave their trash right there—they don't even throw it in the garbage. We got guys that piss in bottles, and instead of pouring it in the toilet, they just throw it in the trash can. I mean, that's pure laziness! It's like I'm walking a circle. I have to walk that circle all day long, continually picking up behind people.

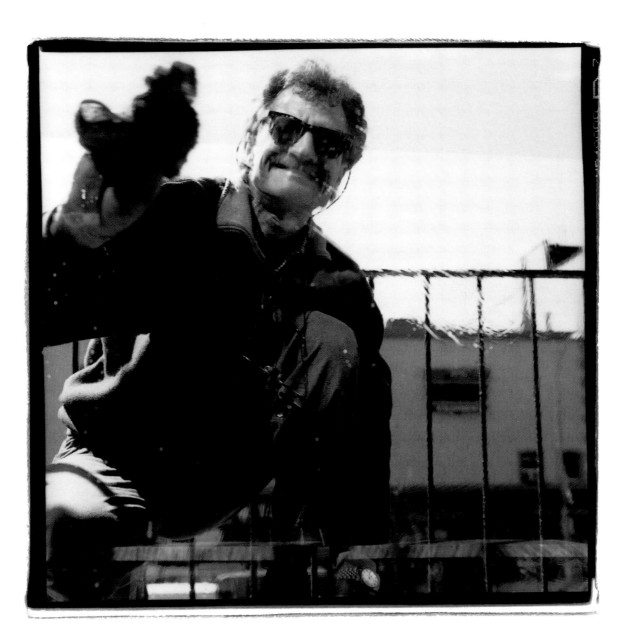

I was born in Russia and came to the States in 1980. I moved to the Sunshine Hotel about a month ago. I had been clean for a long time, living with my family in New Jersey and working as an architect. Most junkies who've been clean have this recurring dream where they just get a bunch of money and rent a room and go off to their fullest heart's desire. I'm realizing that dream right now.

The first time I saw this place, it just blew me away. I had no idea that stuff like this was still possible—people living in cubicles. The hotel has eighteen-foot ceilings, and the cubicles are only seven feet high, with chicken wire on top, so it reminds me of the way cattle is kept—in cages. There's no calm, no peace. The Japanese, for lack of space, created little cubicles where you could spend the night. But they were well designed—there was no noise coming through, and a person could be with himself. Here, it's impossible to be alone with yourself. It's just mystifying to me that places like this still exist. Everyone should experience living like this just to know what's still possible in society.

Most of the people just lay on their bed all day watching TV or listening to the radio or staring into space or sleeping. They just keep vegetating in these little cells with the fluorescent light coming through the chicken wire overhead, and that's their life. They just get deeper and deeper into it, until they fall to complete bottom within themselves. They may not look any different from the outside, but their spirit is destroyed. I see it every time I look at the guys who've been here for eleven, twelve, fifteen years—and they're still here. It seems *normal* to them. This place is deadly.

On my wall, there's a painting of Dürer's *Saint Jerome,* who was a hermit who went to the desert to try to seek knowledge and achieve illumination by detaching himself from the world. In a sense, that's what I'm doing here. This, for me, is a break from reality. No one knows I'm here. I can just indulge to the maximum. It's grotesque, and I enjoy it. It's like that movie *The Cook, the Thief, His Wife & Her Lover*—just in the way that their experience was so disgusting, so grotesque, but they made an art out of it. In the same way, I'm kind of making an art out of experiencing this.

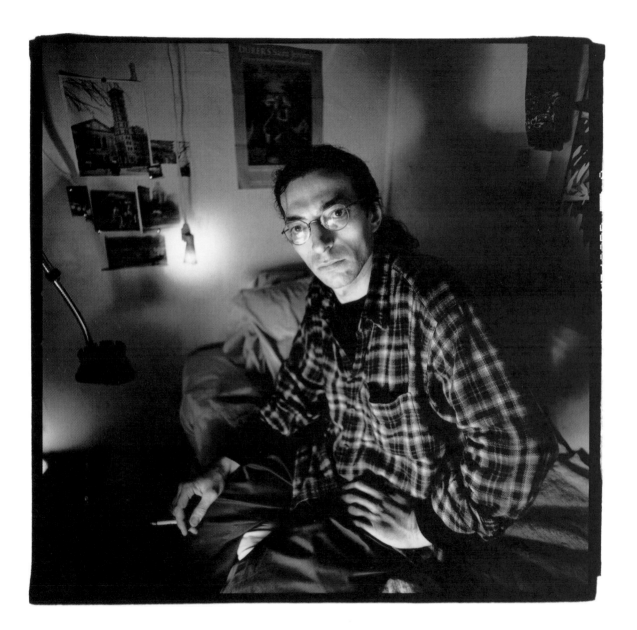

This is where I hang my hat. I put up the pictures to cover the dirt on the wall. Never had a paint job in twenty years. I'm sorry to put it that way, but I asked them and they never give it to me. But I appreciate that the landlord lets me keep my junk in here. It's better than nothing.

I feel like I want to dance, go out to parties like I used to do when I was young. All I see when I get up in the morning is men. I don't see—I'm sorry to put it this way—I don't see any good-looking ladies. But the point is, my life is just about ended. How much more I'm gonna live? Not much. I'm sorry to say it that way, but that's the way it is. Thank you for coming to see me.

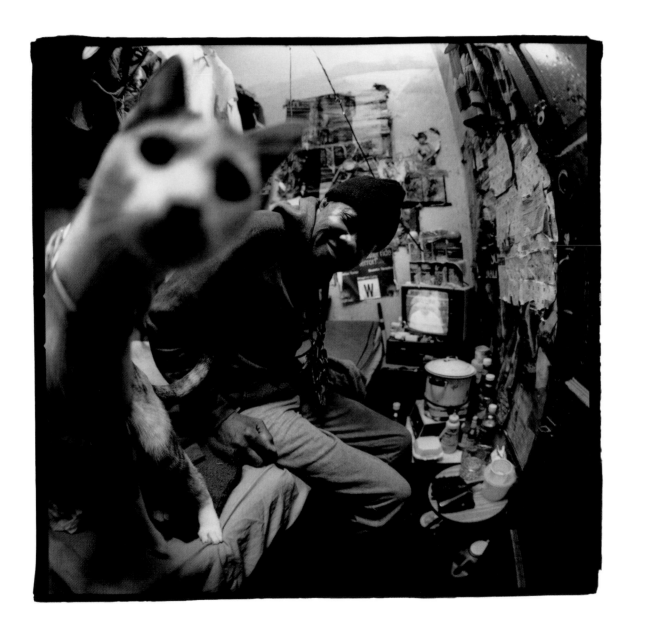

moved into the Sunshine eight years ago, because there was noplace else to go. I was addicted to heroin and didn't want to bother my family anymore.* I've been here ever since, and I'll be here until I die probably.

This is a flophouse, but at least I have my own little room. I can close my door, watch TV. And I've got my babies. Without them, I never would have made it in this place. This is Pretty Boy—he's ten years old. This is Little Bit—he's five. He's a devil, yes you are! These are my friends—all they do all night and day is bring me happiness. If it wasn't for these birds, I wouldn't have made it in this place. These birds have been my life!

I'm in a time zone in here, a dead zone. Every day is the same: I get up in the morning. An hour later, I get my pint of vodka and then I fall out. I get up in the afternoon and get something to eat and then drink some more. It's just like I'm dead. I don't know the difference between what's good and what's bad anymore. I don't know how to better myself, or if I want to. Nothing's ever gonna change. I'm just dead in the water.

When I was fifteen, a friend of mine had a car and we rode by here—*this same hotel*—and we had these rolls of pennies. And this guy that was in the car with us said, "Let's throw the money and watch the bums run for it!" And we stopped the car and threw the money, and the bums started running, grabbing the pennies. We thought it was so funny. God forbid I knew I'd end up in this same damn place. This is what kills me—I think of it every day. I guess God has a way of letting us get what we deserve.

Pretty Boy (in bag). Hit by a car in June 1999.

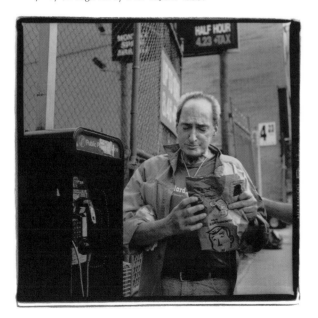

* Giganti is a close relative of reputed mob boss Vincent "the Chin" Gigante. He says that his parents changed the spelling of the family name in 1957.

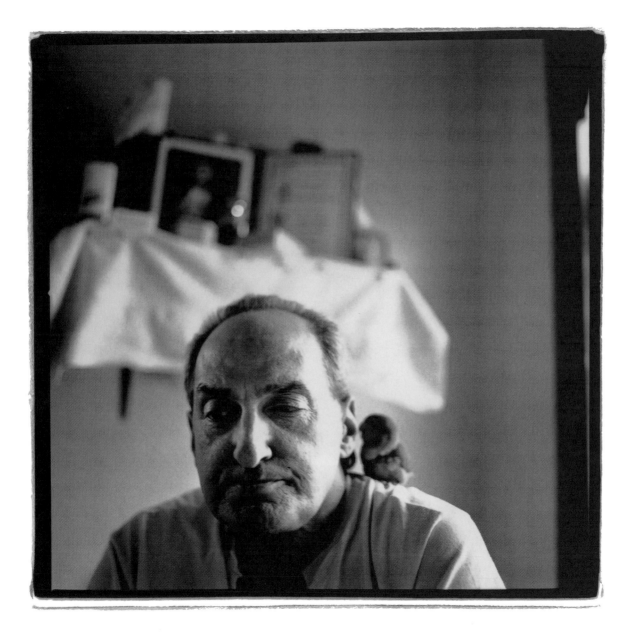

give you answers. My name is Wang Du. Seven years here. I born in Tibet, 1957. My wife is died and my boy died. My family lost. In Tibet, no drink, no smoke. I'm coming here, I'm going alcoholic. I'm thinking about my family. I miss country, too. I was three years old, they killed my father. I remember everything. We had farm, we had horse. Now in Tibet is nothing. Took the Chinese. Took all Tibet in 1961.

I have twenty-six language—Japan, Korean, India, Tibet, Arabic—so many languages! Twenty-six languages, I have it. But what can do now? Nobody give for me no job because I'm drinking. And I'm drink, I'm fight. I have no rent for money. I spend my money on drink, drink, drink, drink. I'm not drink, I can't sleep. What I do now?

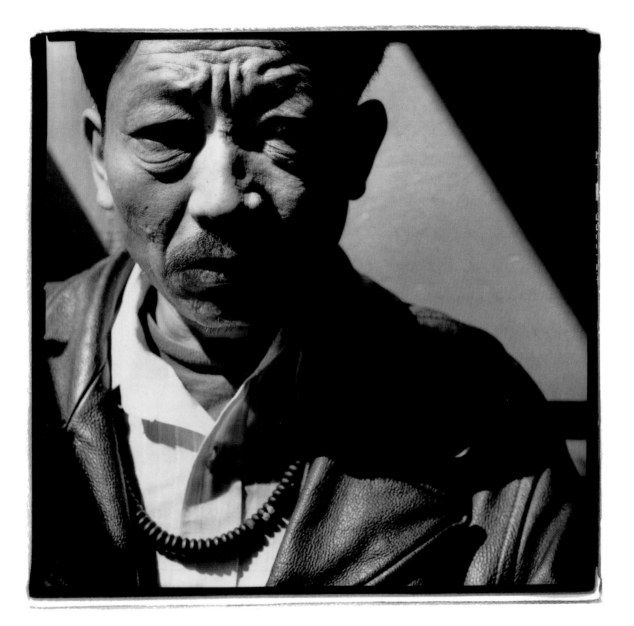

I grew up in Spanish Harlem in New York City in the early fifties. I was a real daydreaming-type child—I was always into imagination and making up stories. When I was in ninth grade, I went to Stuyvesant High School. In '65 my mother and father split, so my mother went to L.A. and we all followed her and left my father in New York. When we got to L.A., I became involved in public speaking and debate, and by the time I got to college, I was the California state champion in expository speaking.

Then I started living what you would call "the hippie life"—I got into music and did acid every day. I got into yoga and meditation. Practiced that for about five years before my life hit a snag. I was in Compton—which is this giant ghetto—and I entered a real internal period in my life. I might as well have gone into a cave. I spent all my time studying Greek mythology, Hindu mythology, Norse mythology—anything that had to do with the past. I started writing haikus and doing intense searching to figure out who I was. Then one day I came up with an amazing discovery: I am Mark Twain. I was Samuel Clemens in my last lifetime. This made a big difference to me.

In 1989, my house in Los Angeles was burned down by a neighborhood gang, so I decided to come back to New York and see if my fortune would fare better. I came to the city and almost immediately got robbed. I had a burned-up flute from the house fire in Compton, and I started playing in the street to make money. I was homeless for about five years when I happened upon the Bowery and cheap rents.

I been at the Sunshine for three years, but now I'm getting evicted. Nathan Smith calls me "the sue maven," because I take guys to court a lot. Started my first suit against the Sunshine two weeks after I got here, for defamation of character and harassment. My second suit was a counterclaim to their claim that I owed them money for back rent. I lost that one, and now I have to leave.

I feel like a lot of people look down their nose at you because you live in the Bowery and you're a "bum." It disturbs me. I'm an artist. If you don't have a thrill about what you're doing, it's just marking time. It's not music. It's not music when you hit every note and just have technical facility. It's music when you have the spirit, when you say something that you feel. So that's the basic message I've learned: The only real success in life is inner success.

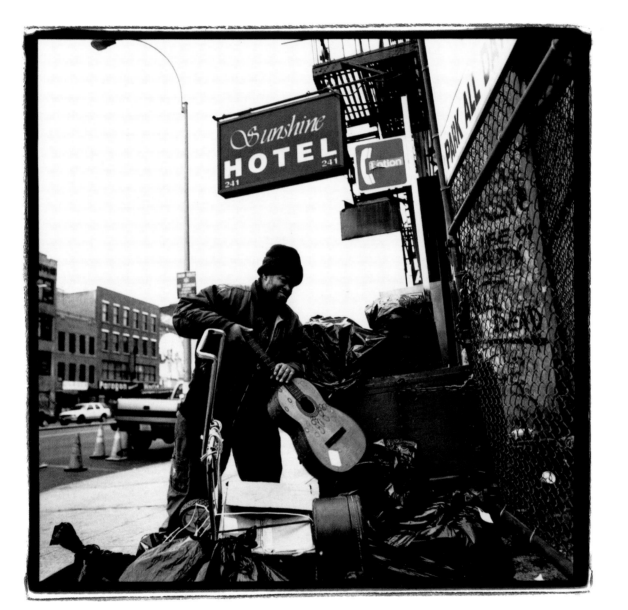

lost my mom when I was fourteen years old. I still don't really accept it. After that I went to the children's shelter on 104th Street and then into a group home. Eventually I had to leave, and that's when my life of crime started. I met this Italian guy named Bruce and started selling weed and cocaine. I got arrested and they put me away.

A couple of years later, I'm out on parole working as a messenger and I look at a bulletin board and there's a notice about training as a nurse's aid. I sign up and go to school. Start working for an agency. One week they call and say there's a cop that got beat up with a nightstick by some black guy on the 6 train. He was going home from the hospital and the agency was giving him a twenty-four-hour attendant. I didn't want to take care of a cop, but my sister told me I had to, so I went.

I really enjoyed taking care of this guy. He used to shit—oh, man, this guy used to shit anything you put into him. But I grew to love him. I loved him because he could have really been prejudiced, because a black dude beat the man half to death. But he wasn't. I used to push him in his wheelchair and he would wear this hockey helmet. And me and him became real, real cool. I remember at Christmas he bought me a stethoscope and a set of twelve books on medicine. He said, "Man, maybe one day you'll study to become a doctor." We became really . . . it was, like,

some days I wouldn't even go home on my day off. He was up in Port Chester, and the whole town knew me. And here I am taking care of a cop, and all these fucking cops come up there every weekend to see him and I'm just hiding out upstairs—it felt like they were coming to arrest me.

So he started getting well, you know. On my last day, he started crying, telling me to move into the area, to stay with him. But I had gotten hot for New York. I had saved up about twelve thousand dollars in a shoe box. Went back and started selling drugs and drinking. Pretty soon, all my money was gone. Started living in the streets, and I became really dangerous—carrying guns, shooting people. I was notorious. Killed three people.

I went to prison. When I got out, I was looking at the *Daily News* and I see: ROOM FOR RENT, TEN DOLLARS A NIGHT. So I come down here. November 29 of this year it'll be four years. Now I'm thinking maybe I'll go back to nursing. To this day it's my first love. I would never in my born days think that I would want to be cleaning some guy's ass for a living, but I guess it's my good deed in life. Thank you for letting me get this off my chest.

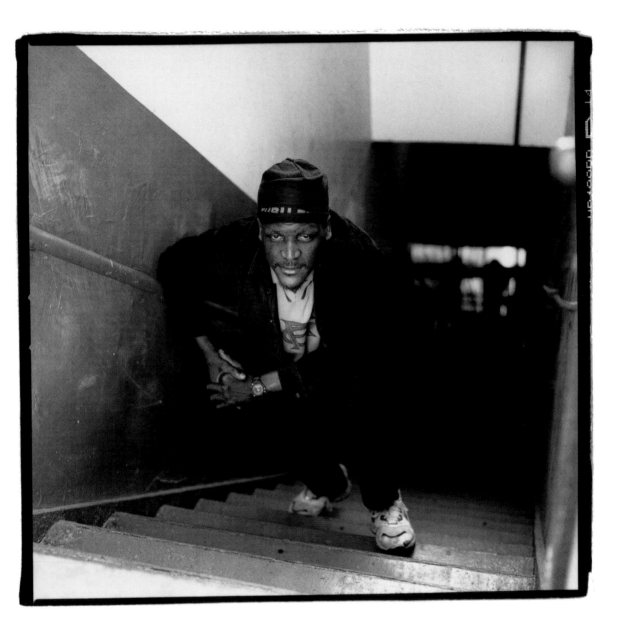

I'm fifty-seven years old. I grew up right down the street in Alphabet City and then went into the service. I spent ten years, eleven months, fifteen days, thirteen hours, and twenty-seven minutes in Uncle Sam's army. Two tours in Vietnam. Former police officer. Former military man. Been married four times. Single at the present time. Seven children, nine grandchildren.

I moved into this hotel in May of '93 and stayed here until July of '97, when I moved to Somerville, South Carolina. Came back the first of this month to see Nate. I heard Nate had cancer, so I called that Thursday and said, "Nate, I'll be there Sunday. Have a room for me." I love him like a brother, I swear I do. And I missed him. I really missed him.

This is my extended family. Bruce is like a brother; Nate's like an old uncle; Tony Bell was my drinking buddy. I lived across the hall from him and used to make the runs for his vodka. Used to make other runs, too. Bruce ran for beer and cigarettes, and I ran for drugs and booze.

Those were the good old days. Camaraderie is no longer here. I been back a month, and it's not like it used to be. Things have changed in the Sunshine. It's not like it used to be. It used to be you could walk out of your room and leave your door open and nobody would go in. Now it's different. I don't trust the people here anymore.

Now there's another person doing the drug runs. I left a legacy. He picked up the torch and now he's running with it. But everything is so modern now. You beep the man and he calls you back. You tell him how much coke you want, and he comes by in a car and drops it off. Technology has just taken over! Where's the energy? They've taken all of the mystery and the intrigue out of it! Walking down the street with drugs in your pocket, there was excitement! "Is that a 5-0 on the corner?" It kept your mind active. Now it's like shopping in a friggin' catalog. Pick up the phone, put in your order, and it's delivered. They've taken the fun out of drugs, you know?

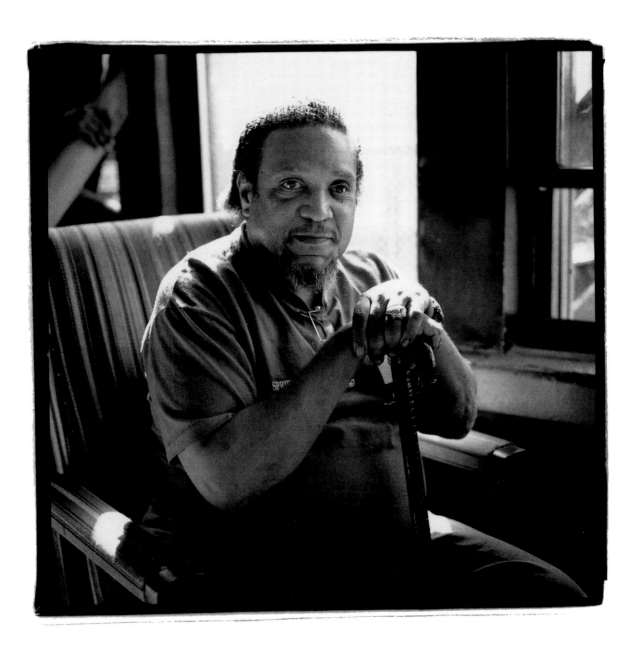

I've always been a loner, a dreamer. My mother was an alcoholic, my father was something of a tyrant, and I just never fit in. So I moved here in '61. Started off with these crazy, soaring ambitions of trying to figure out *everything*. I was on that old, impossible quest for "truth"—like that song "What's it all about, Alfie?"—who hasn't wondered what it's all about? I was reading Lao-Tzu—beautiful! lucid!—and Emerson. I had some fierce, crazy ambitions about learning how to think—how to *really think*.

At first it seemed like I was making some progress—it was intoxicating! But I underestimated the complexity of the whole affair. For every little answer I found, ten new questions would open up. After a while, it just started to seemed like some crazy pipe dream. I figured there'd been a lot more substantial heavyweights by far than me through history and they didn't seem to come up with the "big answers"—so where did I get off thinking I could? Anyhow, I became disillusioned. Started drinking. And here I am. Nothing remotely heroic. Sorry I'm not more loquacious—maybe I feel like I don't have anything to be proud of. It seems like one of those stories better left untold.

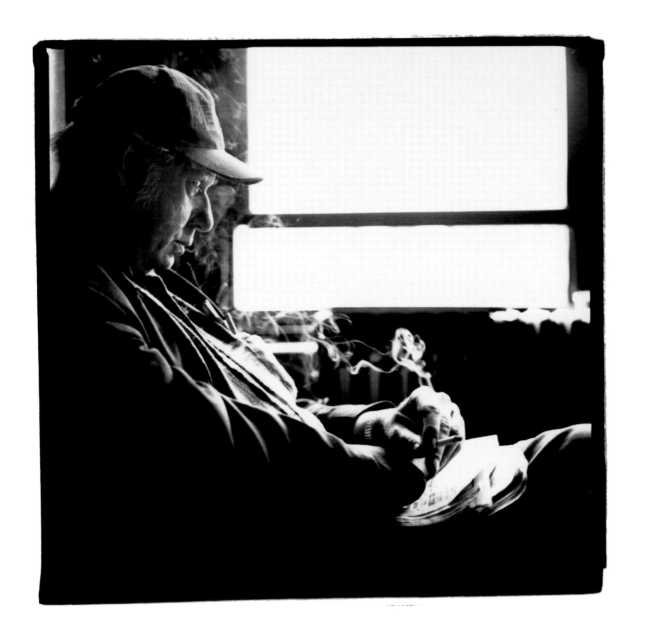

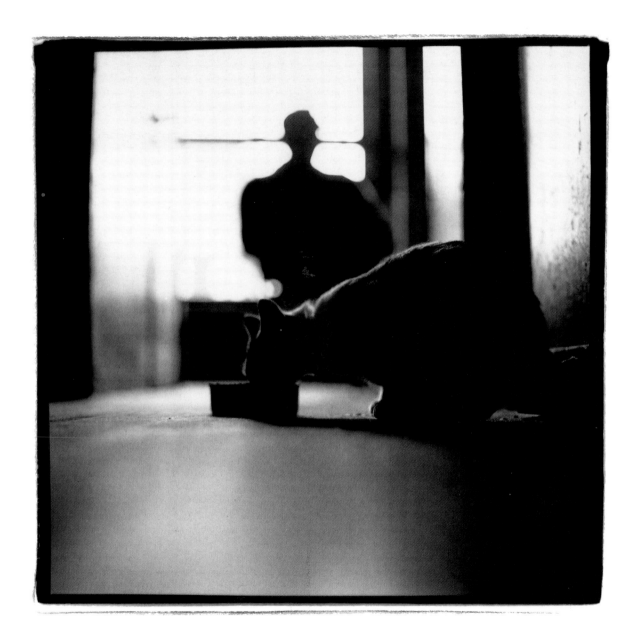

This book has been nearly three years in the making. I'd been keeping a folder of newspaper clippings on flophouses for years. In the spring of 1997, my colleague Stacy Abramson tripped over the file and headed down to the Bowery to investigate. She was intrigued by what she found, and we decided to make a radio documentary.

We spent several months trying to record in the hotels, with little success. Owners were wary of letting reporters in—mostly because of the variety of illegal goings-on inside. The residents seemed equally unenthusiastic about participating in the project.

One morning in early January 1998, we went back into the Sunshine Hotel for our third try. This time we were greeted by desk clerk, manager, and longtime resident Nathan Smith. It was love at first sight. Nate is one of the world's great characters—a brilliant storyteller, a keen Bowery historian, and an all-around amazing human being. Nathan convinced the owners of the Sunshine to give us complete access to the hotel. He let the hotel's residents know that we had his unequivocal blessing. The Sunshine opened up. We spent the next two months at the flop, recording day and night.

Our radio documentary, "The Sunshine Hotel," narrated by Nate Smith, premiered on *All Things Considered* on September 18, 1998. An accompanying oral-history piece with photos by our friend and collaborator Harvey Wang ran in the *New York Times* "City" section that same month. Soon after, we were approached to write *Flophouse*. For this book, we wanted to document as many of the hotels as possible. We circulated tapes of our documentary and copies of the *Times* piece around the Bowery. Doors slowly opened up.

Flophouse focuses on the four hotels we managed to gain access to: the Sunshine, the White House, the Andrews, and the Providence. In the first three, we were allowed to work freely. Harvey and I had to pose as tenants to document the Providence.

The oral histories are edited transcripts of interviews that ran anywhere from ten minutes to four hours. Most lasted about forty-five minutes. Each resident we spoke with received a thirty-dollar food certificate at a local deli to compensate him for his time. We tried to stay away from residents who seemed more interested in the certificate than the project, or who were too drunk or high to understand what we were doing. The book is slightly skewed toward the more stable, sober, and sane residents of the hotels. We have also included a disproportionate number of long-term tenants. Despite this, I think we've captured a fair sense of the character of each of these places. I believe that the stories are honestly told.

In all, we interviewed close to one hundred men. We were able to include only fifty in this book. To

those residents who did not make it in, we extend our deepest gratitude. This is a reflection not on you or your story, but on the constraints of space.

Flophouses are a haven for loners; the cubicles are occupied by fiercely independent and private men. I'm grateful that the residents of these Bowery hotels chose to open their lives to us. I hope that they are as proud of this book as we are.

—Dave Isay / January 2000

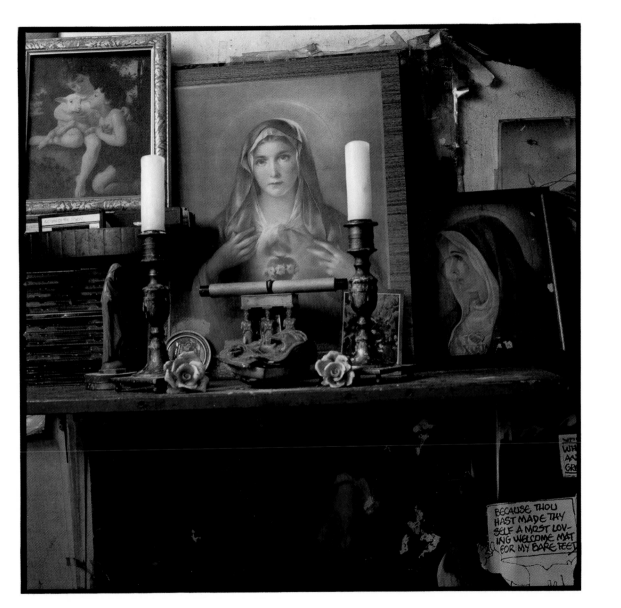

BECAUSE, THOU
HAST MADE THY-
SELF A MOST LOV-
ING WELCOME MAT
FOR MY BARE FEET

When I was fifteen years old, my father caught me in bed with a jug of vodka and ran me out of the house. I wound up here a few years later. Stayed in all these flophouses up and down the Bowery. I was thrown out of every one of them—*every one of them!* One night I had a jug of wine, and I was sitting in the park. A guy wanted a drink, and I says, "No," and he took a knife and stabbed me in the belly. And I came to the Bowery Mission doors here holding my gut. Blood had squished into my shoes. I knew when I knocked on that door that I would find help. That was the end of my flophouses. It was the turning point. The Lord grabbed ahold of me and I was his! Amen.

There are a number of organizations that provide services to men on the Bowery. To find out how you can help, contact any of the following:

THE BOWERY MISSION
227 Bowery / New York, New York 10002 / (212) 674-3456

THE BOWERY RESIDENTS' COMMITTEE
30 Delancey Street / New York, New York 10002 / (212) 533-2020

THE HOLY NAME CENTRE FOR HOMELESS MEN
18 Bleecker Street / New York, New York 10012 / (212) 226-5848

PROJECT RENEWAL
200 Varick Street / New York, New York 10014 / (212) 620-0340

To learn more about the work we do at **Sound Portraits Productions** or to order CDs of the radio documentary "The Sunshine Hotel," visit us on the Web at www.soundportraits.org.

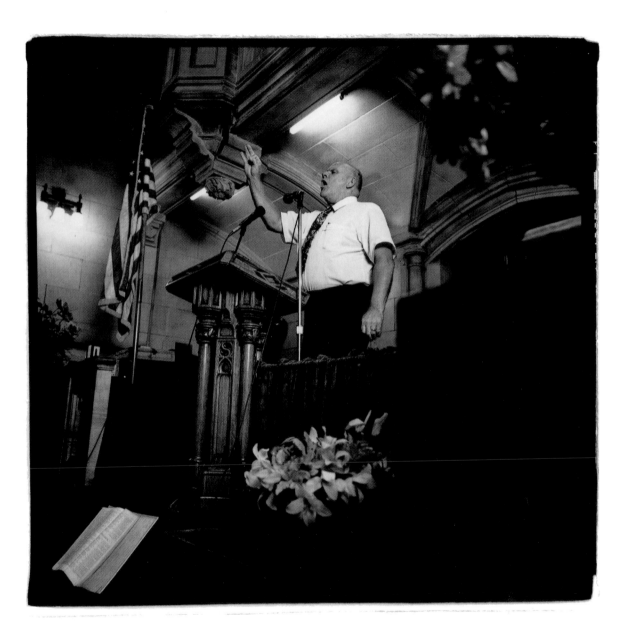

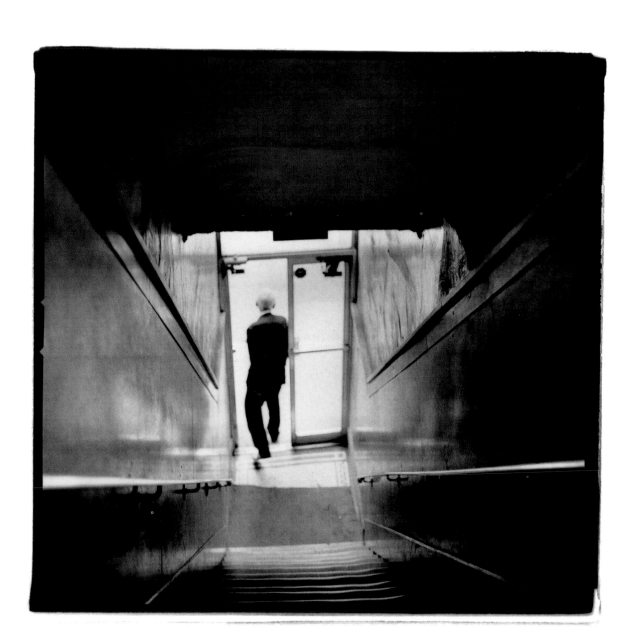

DAVID ISAY is the executive producer of Sound Portraits Productions, an independent production company dedicated to bringing neglected American voices to a national radio audience. His radio documentary work has won almost every award in broadcasting. He lives in New York City.

STACY ABRAMSON is a producer at Sound Portraits. She lives in New York City.

HARVEY WANG is a photographer and Emmy Award–winning filmmaker. His work includes *Harvey Wang's New York* and *Holding On*.

A B O U T T H E T Y P E

This book was set in Optima—a sans serif typeface with a neoclassical flavor. It was designed by Hermann Zapf in 1952–55 and issued by both Stempel and Linotype in 1958.